IMAGES
of America

NEVADA CITY

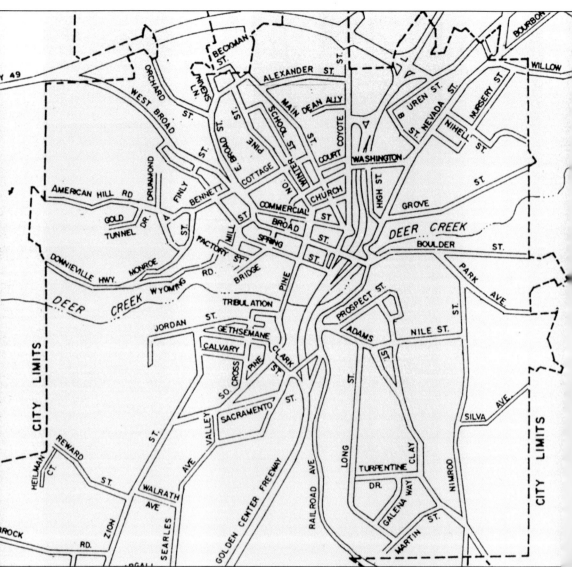

Nevada City's historical district is in the heart of the city and attracts tourists with its unique charm and atmosphere reminiscent of the gold rush. Today's business district boundaries have not changed much since the 1850s, when it was a boom town. After fires in the early years, Broad Street became the more important central commercial street in town, outstripping the once busy and influential Main Street.

ON THE COVER: This undated photograph shows miners posing at the Lecompton Mine on the south side of Deer Creek in the Nevada City Mining District. The mine veins were opened by an inclined shaft in several short tunnels from creek level. The Lecompton was discovered in 1857, and by 1863 the rich quartz mine had produced $230,000—almost $5 million in today's money. In 1917, the mine was owned by James J. Ott.

IMAGES
of America
NEVADA CITY

Maria E. Brower

ARCADIA
PUBLISHING

Published by Arcadia Publishing
Charleston, South Carolina

Printed in the United States of America

Library of Congress Catalog Card Number: 2005930091

For all general information contact Arcadia Publishing at:
Telephone 843-853-2070
Fax 843-853-0044
E-mail sales@arcadiapublishing.com
For customer service and orders:
Toll-Free 1-888-313-2665

Visit us on the Internet at www.arcadiapublishing.com

CONTENTS

Acknowledgements 6

Introduction 7

1. First Residents 9

2. Pioneers and Families 15

3. Town Views, Buildings, and Commerce 29

4. Views from Broad Street 57

5. Snow Scenes 73

6. Mining, Industry, and Transportation 79

7. Chinese 101

8. Leisure and Entertainment 107

9. Community and Group Shots 119

ACKNOWLEDGMENTS

To Jim, my husband of 37 years, I give 100 thanks for his infinite patience and many "historical days" (and sometime "hysterical days") as I struggled to learn new scanning skills, and for seeing me through this season of book writing.

I am especially grateful to the Nevada County Historical Society (NCHS) Board of Directors for their vote of confidence and cooperation in making this book possible, using their vast photographic collection at the Searls Library. Special thanks go to Ed Tyson, director of the Searls Library, and his staff of volunteers including Pat Chesnut, Elmabel Rohrman, June Rice, and Louise Beesley. Other individual members of the NCHS who gave their encouragement and assistance: Al Dittmann, Orval Bronson; Brita Rozynski, and David Comstock for his assistance in Nevada City history.

My appreciation is extended also to Wally Hagaman, director of the Firehouse Museum for his expertise in local Chinese history and for furnishing photos of Nevada City Chinese. A big thank you goes to Steve Cottrell for his special historical "facts" assistance, and to Max Roberts for some fresh photographs—just when I needed them, and to Marilou Ficklin.

I also used the resources and the fine historical collection at the Doris Foley Library for Historical Research in Nevada City and their online resources for locating past Nevada City residents. This library is the jewel of the Nevada County Library system and, sadly, underutilized by its residents. Thank you to my assistant at the Doris Foley Library, Steffanie Snyder, who is always a pleasure to work with, and again to Brita Rozynski, a longtime and very knowledgeable volunteer at Foley.

A special thanks goes to native Nevada City resident Ruth (Fitter) Chesney for her time and willingness to interview and share with me her early memories of Nevada City. Ruth, a lovely and talented lady, shared her family photographs and stories from the past century and told of what it was like living in Nevada City as a child. Ruth is 97.

And lastly, my appreciation goes to those early Nevada City pioneers and those who followed. They left us with a rich historical heritage—some by persevering and not giving up on a town that was destroyed by fire numerous times, others by leaving us a written and/or photographic history of the past, both distant and recent.

INTRODUCTION

Deer Creek, a tributary of the South Yuba River, runs through the Sierra foothills. This small creek played an important role in the history of the area that would become Nevada County, California. The county's many rivers, streams, lakes, and creeks were also blessed with an abundance of the mineral that would literately bring the world rushing in—gold!

They came from every corner of the world, many young and some old. These Argonauts lined the banks of the Sacramento and San Joaquin Rivers and all of their tributaries in a mad search for gold. With such a large influx of men working the rivers, the easily accessible placer gold along the streambeds was soon exhausted. The gold-seekers moved on, expanding their searches into the higher elevations of the Sierra foothills. Late in 1848, a couple of men ventured into what would become Nevada County. One of them panned on Deer Creek, finding traces of gold but no rich deposits. He decided to move on, fearing that, with winter approaching, he would be stranded in the mountains until spring.

In September 1849, others came to what would become Nevada City. Miners John Pennington, Thomas Cross, and William McCaig built a cabin at the confluence of Gold Run and Deer Creeks after finding gold on two of its branches. Another miner named Hunt discovered rich gravel deposits along the same creek. Others soon followed, and in October, Dr. A. B. Caldwell opened a store (where Trinity Episcopal Church now stands on Nevada Street) a short distance upstream to sell supplies to the miners. This settlement became known as Caldwell's Upper Store, as Caldwell had opened a store previously at Beckville, four miles downstream. Another name used simultaneously was Deer Creek Dry Diggins. This name indicated that most of the gold was found in seasonally dry ravines, not in the creek bottoms. Thus, the gold-bearing quartz had to be moved down to the creek to be washed.

Men stayed through the winter, unwilling to give up such rich finds. The winter of 1849–1850 was very severe, and about 1,000 men worked under very adverse conditions in the icy rain, when the water poured down the gullies. They holed up during snowstorms. Still, new arrivals braved the winter, fighting their way up muddy trails that led to the booming settlement of tents and hastily built huts of brush and branches.

By 1850, the population of Nevada was estimated by the miners living there to be between 6,000 and 16,000, making it the third-largest town in California, after San Francisco and Sacramento. Although the federal census for 1850 lists fewer than 3,000 for Nevada Township (consisting of the small commercial section only), a majority of the men worked the nearby creeks, rivers, and streams, or moved constantly, and were therefore not counted in this census. The original documents of the special 1852 California census were not stored properly. Many years later, when it was indexed, about a third of each page was deteriorated and illegible, so these figures do not give a true count of the population either.

In March 1850, with a booming population well over 6,000, an impromptu election was held at Caldwell's store. About 250 votes were cast, and town officials were elected. A discussion ensued regarding various names the town was known by, and these names were written on slips of paper.

O. P. Blackman wrote "Nevada," and upon being read, it was immediately adopted. No longer a mining camp, the town of Nevada was born.

Residents referred to it as Nevada until 1861, when the newly created territory of Nevada elected that name as its own. After that time, the citizens of Nevada formally added "City" when referring to their town to avoid confusion and especially misdirected mail. The designation was correct, as the town had been incorporated twice by 1853. In the opinion of a local writer, published in 1866 in the *Nevada Daily Transcript*, "Nevada is the prettiest of all our mountain towns. It has many of the features of a city, and can boast churches, a theatre, and hotels that will compare favorably with any in California."

Almost from the beginning, Nevada City was known as "Queen of the Northern Mines." Unlike many other gold rush mining camps, Nevada City grew under the influence and guidance of city pioneers who brought a sense of moral responsibility from their native New England. This gave the town cohesiveness even in its earliest of days. As fortunes grew, so did the town. Built on seven hills, the population would spread out to build homes on Piety, Prospect, Boulder, Aristocracy, Buckeye, Nabob, and Lost Hill, as well as Oregon, American, Bourbon, Canada, Coyote, Cement, Manzanita, Phelps, Oustomah, and Wet Hill.

In the early years, Nevada City suffered seven major fires and each time rose from the ashes to be rebuilt better than before. These frequent fires provided excuses for some to leave and move on to other gold rush settlements. The same fires provided opportunities for those who stayed to rebuild. It was the hardworking industrious people—miners, shopkeepers, businessmen and women, and families that settled here and persevered through both the boom and bust years to make Nevada City the "Queen of the Northern Mines."

One

FIRST RESIDENTS

The American Indian tribes of California occupied the land for thousands of years prior to arrival of the first Euro-American explorers. Unlike tribes in other parts of North America, the American Indians in what would become California had many advantages: a moderate climate, rich soil, an abundance of waterways—both inland and along the Pacific Coast—to fish, and plenty of wildlife to hunt. These natives were a peaceful people at the time of contact, made up of many tribes and language groups.

In the western regions of Nevada County, where Nevada City would rise, were the Maidus and the Nisenans. The southern Maidus were located in the middle of gold country, and the impact on them was greater than on any other California tribe. Their peaceful lifestyle changed overnight and was nearly obliterated by the ever-increasing hordes of miners seeking gold. The American Indians living in the area that became Nevada City gave themselves a new name, the "Oustemahs," meaning near the town.

Unfortunately, the white man brought diseases to which the American Indians had no immunity, and their population was decimated. By the time any great number of settlers arrived in Nevada City, the surviving American Indians had been moved to reservations several counties away. This move was not very successful. Many of the surviving American Indians later left the reservations to find their way back to their Nevada County homes.

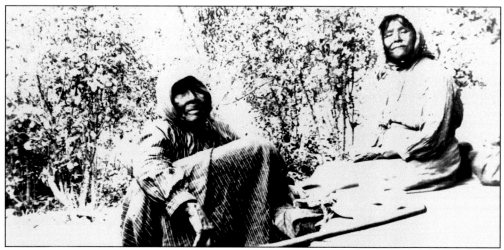

Pictured in the early 1900s are "Old Betsy" Westfield (left) and Josie, the wife of Chief Charlie. As the first white man made his appearance in what became Nevada City, there were 14 American Indian camps existing within a two-mile radius. Betsy was the last of the Oustomah Indians born in a camp located on the site where the Washington School was built. She had many stories to share of the changes that took place, and would recall as a little girl seeing the arrival of the first white man. She was a renowned basket weaver and the town's adopted daughter. One of her favorite recollections was of the tribe taking part in the Fourth of July celebrations. Very different from our present-day parades, the celebrations included a grand tribal war dance and races between the swiftest American Indian racers of the various tribes and the white men. The celebrations were held at Storm's Ranch, with room for 1,000 people, and at the old Hughes Race Track, which seated about 3,000. After attending such a celebration at Storm's Ranch in July 1856, Betsy returned to find that Nevada City had been destroyed by fire. Blind in her later years, Betsy was the last of the full-blooded American Indians of this area. She died in 1923 at the age of 105 and is buried in the old cemetery at Indian Flat. (Courtesy of Searls Library.)

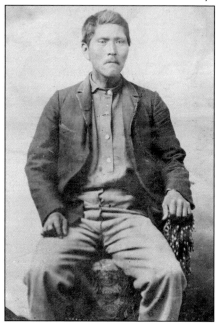

This is a rare tintype of Chief Charlie. Many times, land-greedy, white miners tried to take the land on which the American Indians lived, claiming it was mining ground. The Native Sons and Daughters of the Golden West, along with other townspeople and merchants, aided the American Indians and succeeded in having the land set aside for native inhabitants. In April 1913, Indian agent C. H. Ashbury came from Reno to determine if the Indian land claim was valid and to conduct the proceedings, calling neighbors, city trustees, and members of the Native Sons and Daughters to testify. It was determined that the title of the land had been in the name of their last chief, Charles Culley, and by law reverted to his wife, Josie. She unselfishly gave up her rights so that the other members of the tribe could stay without interference on land where her ancestors had lived for thousands of years. (Courtesy of Searls Library.)

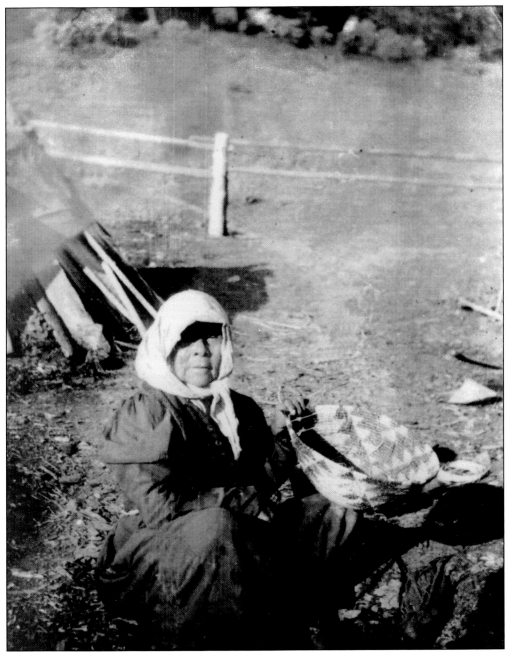

Old Sadie sits weaving a basket at the *campoodie* (settlement). In 1937, the ramshackle houses in which the American Indians had been living were torn down and replaced with cabins funded by the Works Progress Administration (WPA). (Courtesy of Ruth Chesney.)

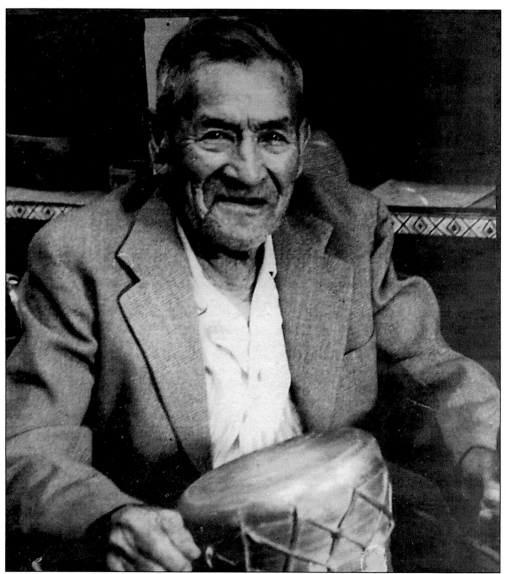

Chief Louis Kelly's Maidu name was Laloak, the meaning of which is lost. He was born in 1885 at Nevada City at the campoodie on Cement Hill Road. Chief Louis Kelly was patriarch of the Nevada County Maidu Indians and father of the last members of the Oustomah tribe. His grandmother was Betsy, and his ancestors included Chief Charles Culley and his wife, Josie, Betsy's regular companion. Kelly learned the ancient ways, the lore and legend, from his grandparents. He could relate stories about every wild animal, and learned the gathering of herbs and hunting. He recalled the story of Nevada County's "Bigfoot," a giant man feared by the Maidus. Chief Kelly lived to be 95. He died in 1980. (Courtesy of Searls Library.)

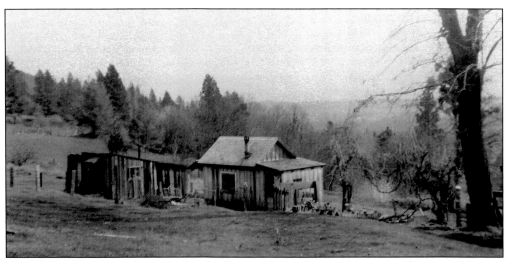

This 1920s photograph shows the last few houses left standing at the campoodie, west of the city. By the time a special census was taken of non-reservation Indians in California in 1905–1906, there were only a total of 16 American Indians living at Indian Flat, a short distance above Nevada City. At the time of the census there were no mixed-blood heads of families, all were pure American Indian blood. The local Maidus had no written language, and our information about their early lives prior to the settlement of the white man comes from archaeology, ethnography, and historical accounts from the American Indians still living there. The American Indians were hunters and gathers who used bow and arrow and the sling shot. They told of using gold-bearing rocks for their slingshots, as they were heavier and more effective than lighter rocks. They would soon learn the value of the gold, however, and that would mean the end of life as they had known it for generations. (Courtesy of Doris Foley Library.)

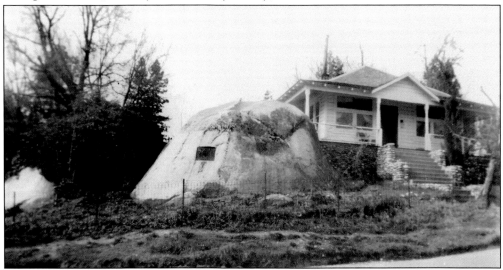

Medicine Rock, the large boulder in the front yard of a home on East Broad Street, is all that remains to testify to the once-large American Indian population. Laying on the Medicine Rock's hollow top—with the warmth radiating from the rock below and the sun above—was therapeutic. The rock is also one of the few natural landmarks that early pioneers would find familiar and recognize, since much of the town and surrounding landscape having drastically changed over the last 150 years. (Courtesy of Doris Foley Library.)

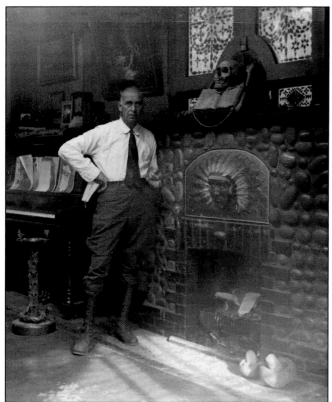

Victor Granholm, a sailor, was born in Finland and came to California in search of gold. He met and married Jenny Robinson, said to have been the first white child born in the city of Grass Valley. They had eight children. The youngest, Elmer Robinson Granholm, wandered over the hillsides as a child and developed a love for nature and American Indian culture and artifacts. In his boyhood, he collected arrowheads, pestles, and other relics that he found. He became an authority on California American Indian lore, especially of the Nisenans. Granholm, shown here, is standing in front of the fireplace he made incorporating arrowheads that he had gathered in Nevada County. (Courtesy of Doris Foley Library.)

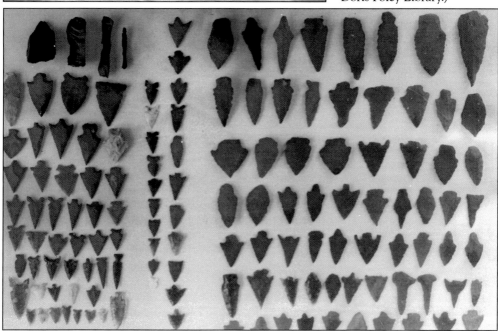

Granholm made casts of the arrowheads he found and reproduced them in clay. His home was a private museum where he displayed arrowheads and the collections of the many Maidu Indian relics he had collected. (Courtesy Doris Foley Library.)

Two

PIONEERS AND FAMILIES

Most of those who came to find gold arrived with the intention of getting rich and returning home. Few envisioned California as a place to settle. The mining camps that were springing up overnight were hard, rough places to exist, crammed with temporary shelters. The populace moved on when the shining minerals got scarce. The elements and lack of water (or too much of it) were major factors in the early years. Prices for ordinary goods and food were exorbitant. Early successes were usually due to luck rather than technique or skill, and the "easy pickings" were quickly depleted. Many became discouraged and looked for other ways to make a living—or at least enough money to get back home.

Many did return home after experiencing California. But others found it to be a land of many opportunities and a good place to settle. Some would return home to bring back a wife or family, there being few available women in early California. The first female settlers had as much opportunity as the men to reinvent themselves, and freedom to do whatever they were capable of. The lifestyles and comforts of home were lacking in the early years, and the female presence helped settle and civilize society in the frontier state.

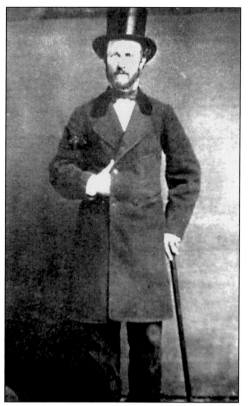

Young Niles Searls came to California in 1849 with his lifelong friend, Charles Mulford. Searls's diary of their overland adventures and letters home tell of near death by scurvy, fever, and cholera. The men originally had no intention of staying in California, but both would return home, marry, and bring their wives back to Nevada City. (Courtesy of David A. Comstock.)

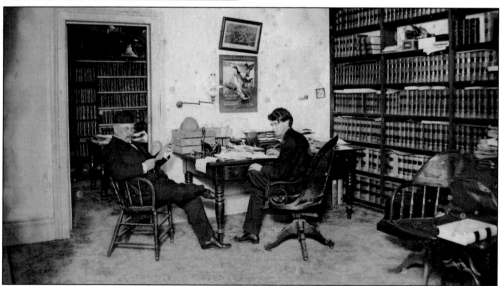

Built in 1873 by Judge Niles Searls, this law office is on Church Street across from the courthouse. Three generations of Searls attorneys conducted a law practice in this two-room, one-story brick building. Owned by the Nevada County Historical Society, it is one of several original buildings still standing, with iron shutters on the beautiful, old-pane glass windows. It houses the society's library and large collection of Nevada County historical material. Judge Searls is seated on the left, and the younger gentleman is probably his law clerk. (Courtesy of Searls Library.)

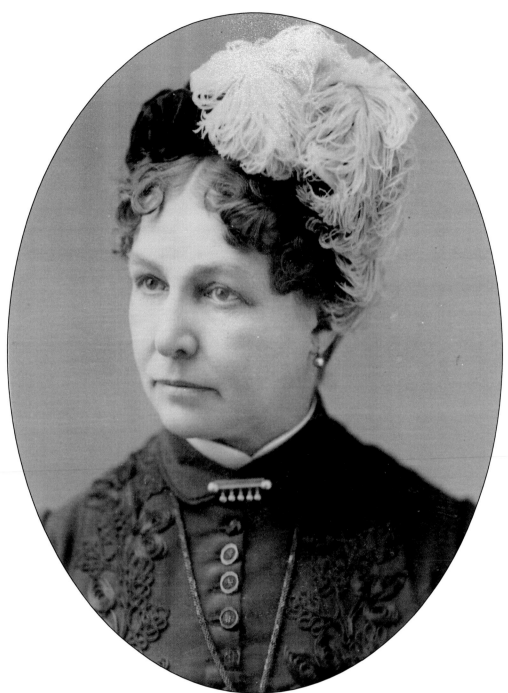

On May 25, 1853, Niles Searls went back east to marry his cousin Mary Niles in Rensselarville, New York. Mary Niles Searls arrived in Nevada City in October of that year, traveling west by steamer with her husband and longtime friends, Deb and Charles Mulford, also recent newlyweds. Mary wrote in a letter back home saying, "We were often told that our arrival in Nevada would be an *era*, as there had never come more than one lady at a time, and those not very frequent." (Courtesy of Searls Library.)

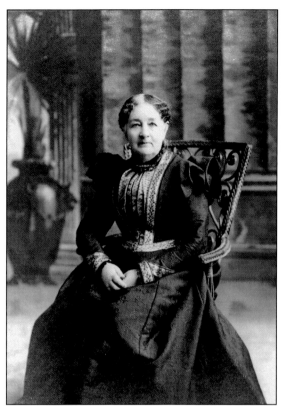

In 1847, pioneer Tallman Rolfe came west and became a printer on Sam Brannan's *California Star* newspaper in San Francisco. Shortly after the gold rush started, he followed those who deserted the bay town for the mines. His brother Ianthus Jerome Rolfe soon joined him. In 1853, the brothers, with partner Warren B. Ewer, bought the *Young America* newspaper in Nevada City, then established *The Nevada Democrat*. Ianthus returned to Massachusetts to his childhood sweetheart, Emily Lindsey, married, and brought her to the roaring mining town of Nevada City. (Courtesy of Searls Library.)

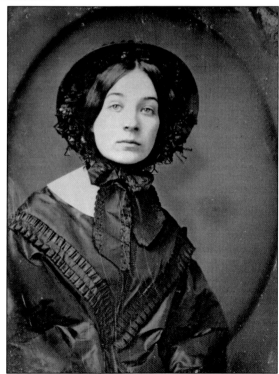

Emily Rolfe is pictured shortly after she arrived in Nevada City in 1853. (Courtesy of Doris Foley Library.)

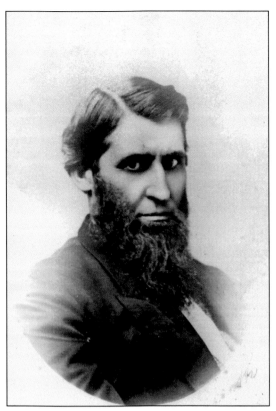

In July 1849, civil engineer Charles Marsh first prospected along Deer Creek. In 1850, Marsh, with William Crawford and J. S. Dunn, conceived the idea to build a ditch to bring water from Rock Creek to the Coyote diggings nine miles away. Costing $10,000 to build, the investors got their money back in six weeks. In 1851, Marsh was elected county surveyor and surveyed the western boundary of the county. In 1861, Marsh was elected director of the Central Pacific Railroad (CPRR) with Stanford, Huntington, Crocker, and Hopkins. (Courtesy of Searls Library.)

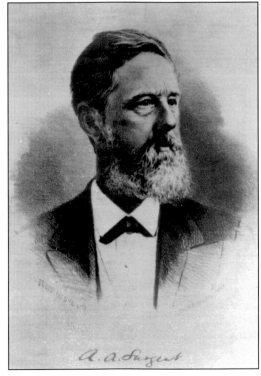

Forty-niner Aaron A. Sargent arrived in the town of Nevada in 1850 and was a journeyman printer. He started and edited the first newspaper in the county and city, *The Nevada Journal*. In 1854, Sargent was admitted to the bar, and in 1855 he was elected District Attorney. He was elected to the House of Representatives in 1861, 1869, and 1872, and the first person elected to the U.S. Senate from California. His other accomplishments included authoring the bill that created the first transcontinental railroad, writing the first history of Nevada County, and proposing the federal women's suffrage bill and amendment. (Courtesy of Ruth Chesney.)

Ellen (Clark) Sargent arrived in Nevada City on October 23, 1852, accompanied by her husband, Aaron Sargent. Ellen founded the Nevada County Women's Suffrage Association. This organization became part of the statewide association that was instrumental in winning the right to vote for women. Ellen Sargent was one of the most influential women in the California suffrage movement. Susan B. Anthony was her contemporary and personal friend. Both of the Sergeants died before realizing their dream—the passing of the 19th Amendment on August 25, 1920. (Courtesy of Searls Library.)

He was said to be one of the most popular physicians ever to practice in Nevada City. Native son Carl Lewis Muller was born in Nevada City in October 1861, and obtained his early education locally. He was among the students in the first graduating class of Nevada City High School in 1880 and went on to teach school and study medicine. He attended Cooper Medical School in San Francisco and Jefferson Medical College in Philadelphia, and obtained his medical degree in 1888. Returning to his hometown, he opened an office on April 20, 1888, in the Roberts Block on Broad Street. (Courtesy of Searls Library.)

David Fulton Douglas, born in San Joaquin California in 1858, stands as a model of the early California West. In 1883, he arrived in Nevada County as a Wells Fargo messenger, covering routes in Nevada, Sierra, and Plumas Counties, and guarding gold shipments for the Nevada County Narrow-Gauge Railroad and for the Southern Pacific Donner Pass route. Douglas was elected sheriff of Nevada County in 1894. In 1896, there were a series of holdups on San Juan Road near Lake Vera. On a tip that the bandits were camped out nearby, Douglas headed out alone in his buggy in the vicinity of Cold Springs. In a duel with the men, Douglas was killed, as was one of the bandits. A theory was that a second bandit had killed Douglas and escaped. A monument stands on the spot where the brave sheriff was gunned down on July 26, 1896. A plaque also stands where the bandit died. (Courtesy of Searls Library.)

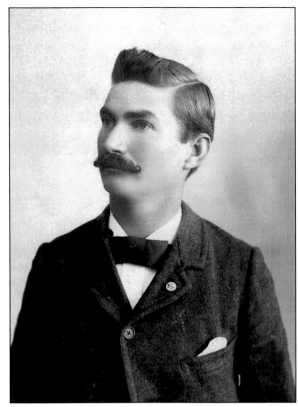

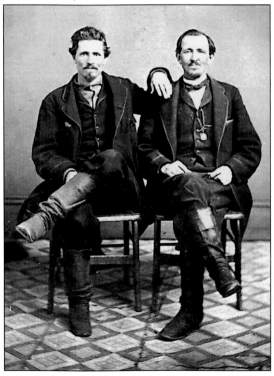

Brothers Martin Luther (M. L.) and Daniel were two of eight children born to John and Rebecca Marsh in Middletown, Ohio. M. L. came to California in 1850 and went into the home-building business with partner Robert Blossom. He sold out to Blossom, who remained in Sacramento and became a millionaire, and later came to Nevada City. After pursuing other opportunities, M. L. returned to Nevada City and, with A. B. Gregory, bought a lumber mill. Together they built a lumber empire. This photograph is said to have been taken in Nevada City on Christmas Eve 1862, after a trip east. (Courtesy of Searls Library.)

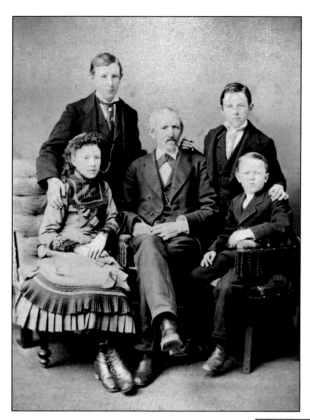

In 1862, returning to California with his brothers Daniel and John, M. L. Marsh fell in love with Emma Ann Ward while traveling with her family on the same ship sailing to California. After the ship docked, Emma's family departed for their destination in Santa Cruz and Marsh went to Nevada City. After two years of courtship, the couple married, and Emma came to live in Nevada City in the house M. L. had built for her. Pictured above with M. L., their four children, from left to right, are Maria Jane, Sherman, Charles, and John. Emma was struck by typhoid fever and died on July 8, 1873. Following Emma's death, the home on Park Avenue was destroyed and M. L. moved his family to a new home on Boulder Street, which is still standing today. (Courtesy of Searls Library.)

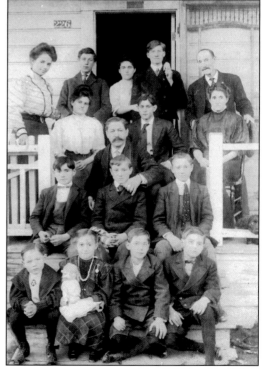

The Chapman family poses in front of the family home on Sacramento Street. Dr. Chester Chapman is seated in center; his mother, Dr. Nellie (Pooler) Chapman, is on the right, and Dr. Allen Chapman is seated in the second row from the top. Nellie Pooler married at age 14, and although she probably did not have much formal education, she learned dentistry from her husband and became the first female dentist in the county. (Courtesy of Searls Library.)

Zeno Philosopher Davis left for California on March 5, 1849, when his young wife was about to become a mother at Young's Prairie, Case County, Michigan. Cleora Adelade "Addie" Davis was born August 9, and at three weeks old, her mother, Sarah, headed west, crossing the plains with the newly born infant in her arms. The family arrived in Nevada City on October 19, 1850. Four generations are pictured here: Addie (Davis) Lester, her daughter Minerva "Minnie" (Lester), Sarah Davis, and great-grandson Lester Barnum Power. (Courtesy of Ruth Chesney.)

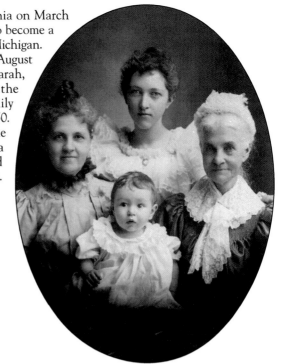

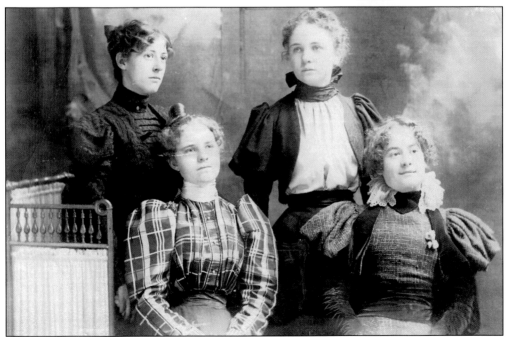

Popular young ladies of Nevada City are (first row) Elizabeth "Bess" Goyne and Gertrude Hampton; (second row) Elizabeth Naffziger and Laura Power (Fitter). On November 30, 1902, Laura Power married Harry Fitter in Nevada City. Her brother was District Attorney E. B. Power, and her sister Frances was a schoolteacher. Elizabeth Goyne also taught school, and in August 1903, married Lawrence C. Kaarsburg. She was the daughter of C. A. Goyne. (Courtesy of Ruth Chesney.)

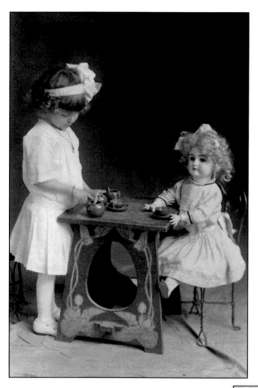

Little Miss Ruth serves tea to her doll. Frances Ruth Fitter (Chesney) was born in 1908 at the same house in which her mother, Laura Power, was born and married. Ruth's father, Henry Fitter, was a mining engineer and worked for the Murchie, Kate Hardy, and other mines. The family would follow to live in the housing provided by the management of the mines. Ruth recalls one of her favorite pastimes as a child was to ride her horse Pumpkin, who was kept in their yard. Ruth and her friend Fidella Legg rode into town, attended dances, and enjoyed winter activities such as ice skating, snowshoeing, and sledding. (Courtesy of Ruth Chesney.)

Pictured here are Charlie Power, left, and Charles Kent. Kent was a Nevada City businessman and owner of the Keystone Meat Market on Commercial Street. During the era of anti-Chinese sentiment that was sweeping California, Nevada City adopted an ordinance prohibiting Chinese within the city limits. In June 1880, while this very issue was being debated, a fire started outside Chinatown and destroyed the Chinese community along Commercial Street. Sites for a new Chinatown were sought, and property owned by Charles Kent on Washington Road (above the junction with Coyote Street) was selected. It later became known as Kentsville, after Charles Kent. (Courtesy of Ruth Chesney.)

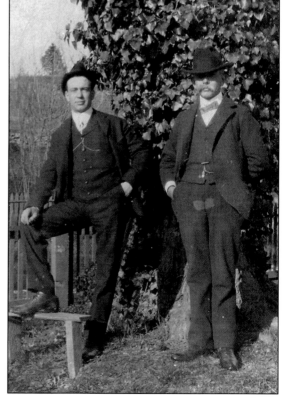

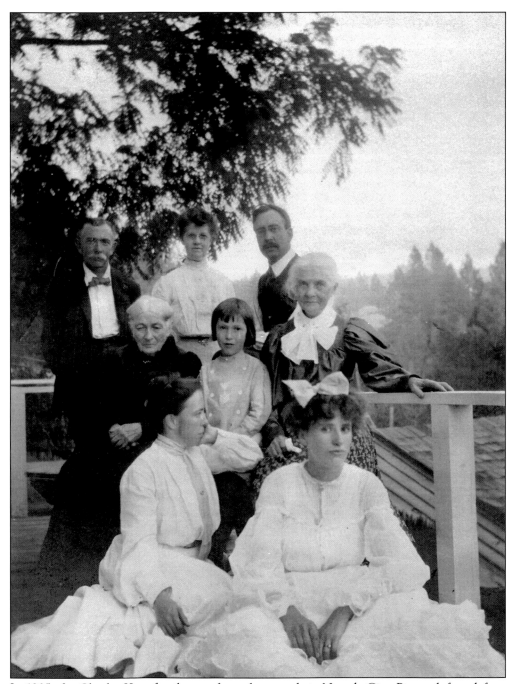

In 1905, the Charles Kent family pose for a photograph in Nevada City. Pictured, from left to right, are members of the Kent, Lester, Power, and Davis families: (first row) Frances Power and Helen Kent; (second row) Julia Kent Lester, Lester Power, and Mrs. Sarah Davis; (third row) Charles Kent, Addie Lester, and Barnum Power. (Courtesy of Ruth Chesney.)

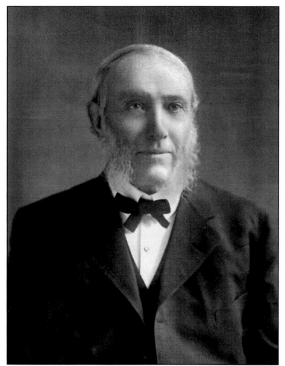

Emigrating from South Wales when he was young, John T. Morgan first lived in the state of Wisconsin. In 1852, he came overland to California, arriving in August of that year. He first settled in Placerville and engaged in mining and blacksmithing, his trade in Wales. In 1857, he married Elizabeth Jane Eddy from Cornwall. In 1858, he moved to North San Juan, but eventually returned to Nevada City, where he became a cashier at Citizens Bank. He was also the township collector and county assessor, and later became president of the bank and a prominent Nevada City businessman. (Courtesy of Searls Library.)

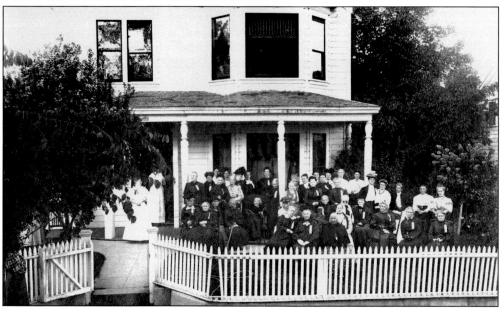

Family members gather in front of the John T. Morgan House at 415 Main Street. John T. and his wife, Eliza, had 12 children—eight of whom survived childhood. Their son David E. followed in his father's footsteps, first mining and then joining Citizens Bank in 1880, where he worked for 40 years. He also became president of the bank until it was consolidated with Bank of Nevada County. David E. married Helen Naffziger and had four children. As a wedding gift, the elder Morgan presented the young couple with a deed to the lot directly across the street from the Morgan home. The large old home became the Clark Apartments. (Courtesy of Ruth Chesney.)

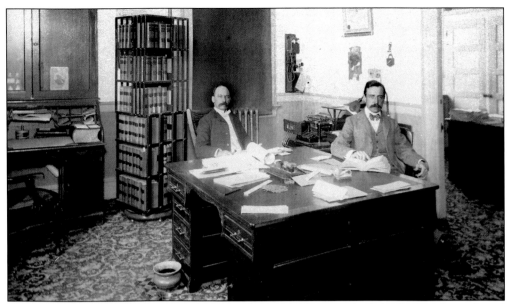

This 1902 photograph shows District Attorney George L. Jones (right), who was later elected superior court judge, serving from 1908 to 1925. He resigned to become president of the Nevada County Bank. In 1938, he returned to law and the bench, retiring in 1947. George's parents were pioneers Dr. and Mrs. W. C. Jones. George's brothers John and Carl followed their father into the medical profession and worked in the Jones Hospital in Grass Valley. Judge Jones lived in Grass Valley until his marriage to Helen Croker Mott in 1905, then purchased a house at 236 Nevada Street where he lived for 50 years. The gentleman at left may be Arbogasts, who was county clerk at the time Jones was serving as district attorney. (Courtesy of Ruth Chesney.)

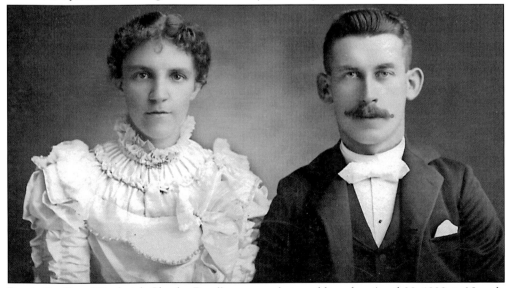

Bessie Snell and Frederick Charles Beadle pose on their wedding day, April 28, 1898, in Nevada City. They were married at the home of the bride's mother, Eliza Snell, on Piety Hill. Bessie was a bookkeeper for Legg and Shaw Company. Frederick was an employee of the Champion Chlorination Works and was the son of Charles W. and Mary Beedle, Nevada City pioneers who arrived in California in 1859. The couple later moved to Gold Flat. (Courtesy of Searls Library.)

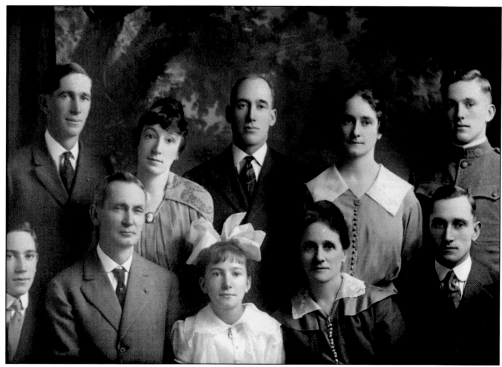

The Fischer family was the first owner of the Plaza Store. Pictured, from left to right, are (first row) Earl, Gustave, Lorene, Ethel, and Gustave Jr.; (second row) Karl, Ethel (Essie), William, Louise (Lola), and Clyde. In 1913, Karl Fischer married Vera Brown at the Brown home on Sacramento Street. The couple returned to Nevada City to live after their honeymoon. (Courtesy of Searls Library.)

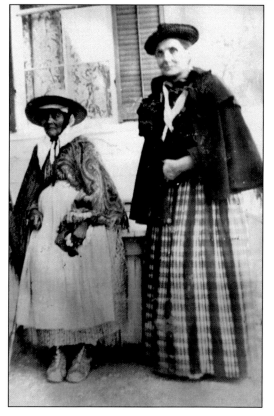

Aunt Caroline (left) and "Funeral" Mary Stockham were beloved characters around town. Mary was eastern born and educated. Rain or shine, she never missed a funeral—whether she knew the deceased or not. Every funeral parlor, church, and lodge saved a seat for her arrival. She wept, wailed, and sang at every funeral, knowing every service by heart. (Courtesy of Searls Library.)

Three

TOWN VIEWS, BUILDINGS, AND COMMERCE

Nevada City is said to be the best-preserved gold rush town in California. This is remarkable, given the town's history of disasters. The entire business section of town was destroyed several times in the early years by fire, and part of the town perished in a flood. Yet rebuilding began before the ashes were cooled, or the mud dried, larger and better each time.

Nevada City appears to be haphazardly laid out; the streets are hilly, with many twists and turns due to the early settlement and mining. The Plaza, now long gone, once served as a central square and the business center, from which roads and trails led to the outlying diggings. Main Street, originally the primary thoroughfare, in a short time was surpassed as Broad Street became the important center in town.

The town sprang up from the banks of Deer Creek, which continued to be an important factor in the life of the town and a natural boundary to expansion. A series of bridges allowed the town to expand to the other side and cross to the roads leading into and out of the little town nestled in the foothills.

Nevada City would become an important trading center for all the mining camps and towns in three counties. Miners came from Dutch Flat, Camptonville, Smartsville, and Downieville to conduct business.

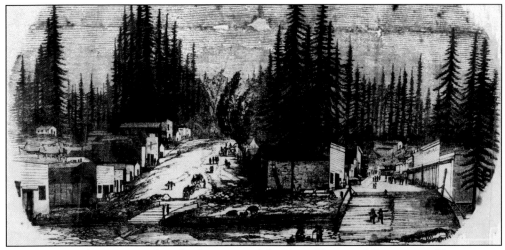

The above wood cut appeared on the front page of the *Placer Times and Transcript*, a "Sacramento City" newspaper on August 12, 1851. The caption read: "Of all the cities in the northern mines, Nevada is by far the prettiest—its localities the richest, and its population the most numerous. It is difficult to say which is the most striking, the novelty or romance of its position. The pines not only surround the city, but the houses are built in the shade of these stately trees. You enter the city by Deer Creek, over which stream two wooden bridges are thrown; the water has lost its purity from the number of sluices engaged on its banks, and though utility has mar'd the beauty of the stream, our reflections are 'Was ever water put to such a use before.' The neighboring hills are rapidly being disemboweled, tunneling and cayoting hills leave these pyramids but skeletons of earth. Our Illustration will convey an idea of the most important part of the city. Trade is brisk and miners prosperous. A visitor in Nevada has 'golden opinions from all men.' " (Courtesy of Searls Library.)

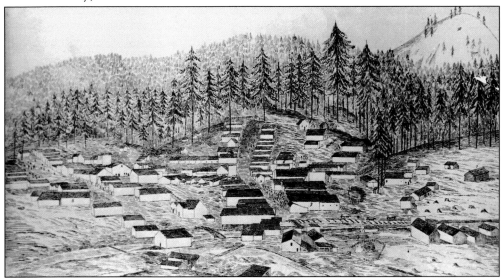

The above sketch shows the town of Nevada City from Prospect Hill in 1851. On March 12, the town would lie in ruins as the result of an incendiary. It started in the Ball Alley, built of wood, as were all the other buildings at the time. The fire burned for seven hours until there was nothing left. Several buildings were torn down in an attempt to stop the fire. (Courtesy of Searls Library.)

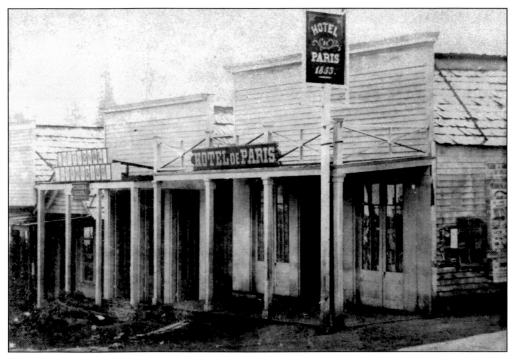

The Hotel de Paris was built in 1853 and was destroyed in the 1856 fire. A description in the 1856 directory of Nevada, Grass Valley, and Rough and Ready makes the hotel sound much grander than it actually was. The close proximity of the buildings made the impending fire unstoppable. The first fire-engine company to occupy its own "house," Protection Hook and Ladder Company No. 1, put up a wooden building next to the Hotel de Paris, rebuilt after the 1856 fire. The first building on Broad Street was erected behind this hotel building in September 1849 by John Truesdale. (Courtesy of Searls Library.)

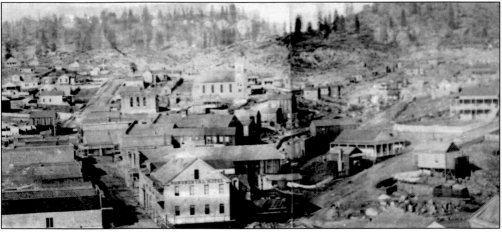

This wide view of Nevada City was photographed prior to the 1858 fire. In the foreground at the foot of Main Street is another early hotel, the Monumental. It was destroyed at least twice, in 1856 and 1858. The proprietors were Andrew H. Parker and Stiles A. Humphrey. Late that year, a new bridge at the foot of Nevada Street was built to connect it with Main. The new bridge occupied a portion of the old Monumental Hotel lot, which the city purchased after the fire. (Courtesy of Searls Library.)

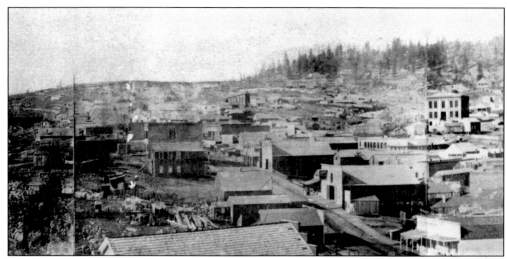

Three views of Nevada City were taken prior to the 1863 fire. This one shows the courthouse in the middle on the right, the plank sidewalk visible in the front. In 1901, a cement walk, coping, and steps leading to the courthouse were built at taxpayer's expense. In less than two years, the sidewalks and coping were cracked and the steps were crumbling. (Courtesy of Searls Library.)

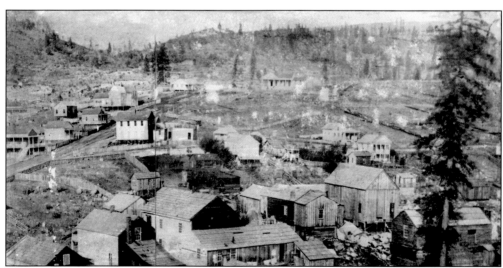

Few trees were left in and around the town of Nevada City by 1863. Besides the lumber needed for building, the mines would use an inestimable amount of timber as well as the advancing Nevada County Narrow-Gauge Railroad's need for wood for fuel and building track. (Courtesy of Searls Library.)

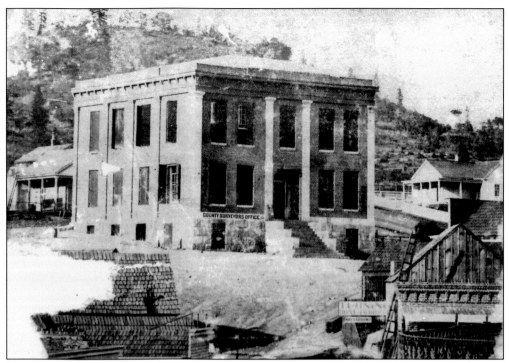

A new two-story brick courthouse was completed just days prior to the July 1856 fire. This is a view of the courthouse that was built after the fire. The building seemed to survive the November 8, 1863, fire—until the front and rear walls of the courthouse came crashing down on the night of November 16. (Courtesy of Searls Library.)

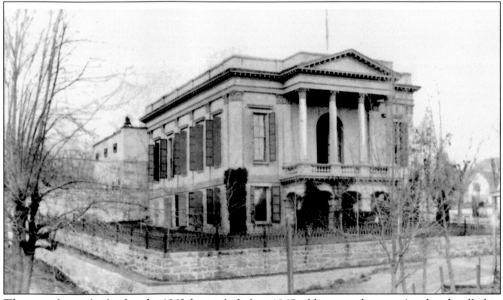

The courthouse built after the 1863 fire included an 1865 addition to the rear. A jail and walled-in area for the prisoners was added. A bell was installed on the top of the addition, formerly used to summon the congregation to worship in the Catholic church. It now sounded to summon transgressors and their defenders to the district and county courts. (Courtesy of Searls Library.)

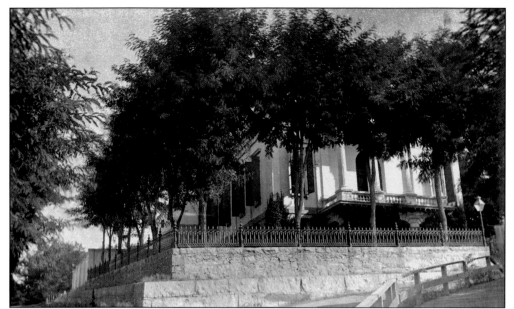

The courthouse occupies the most prominent location—sitting on a hill above the town. This lovely 1864 frontal view shows the courthouse surrounded by trees. It stood until 1936–1937, when the exterior was covered and modernized for an updated look. Another story was added to the jail in 1913, with rooms for "insane patients" and a large jury room. (Courtesy of Searls Library.)

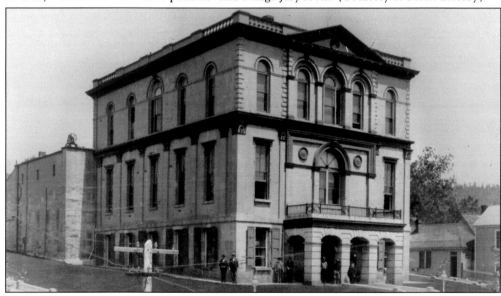

In April 1900, the board of supervisors voted to have a third story added to the courthouse instead of a bell and clock tower. During the six-month renovation, buildings and rooms about town were secured to conduct business. The superior court met at Hibernia Hall on Main Street. The county clerk has his office in the Tower building, also on Main Street. The supervisors occupied the rear or the treasurer's office on Broad Street. The sheriff had a temporary structure erected near the jail, with the recorder occupying a storeroom between Grimes' Clothing Emporium and C. E. Mulloy's store. All official documents used by the various county officials were stored in a room over the Owl Saloon. (Courtesy of Searls Library.)

This is the "modern courthouse" much as it appears today. In 1936, a new facade was added to enlarge and modernize the building. Due to government growth and the need for additional off-site space for other offices, within 20 years the newly remodeled courthouse would again be too small. In 1963, construction of an annex would begin but not open until 1965. The streamlined 1963 annex did not match the 1936 art deco architecture, thereby prompting many comments from tourists regarding a building so out of touch with the well-preserved gold rush town. (Courtesy of Searls Library.)

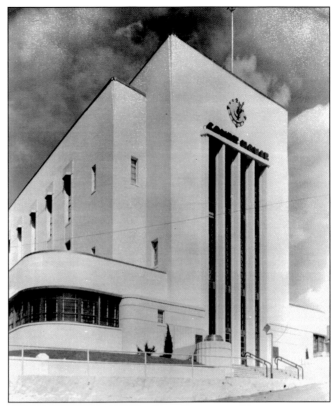

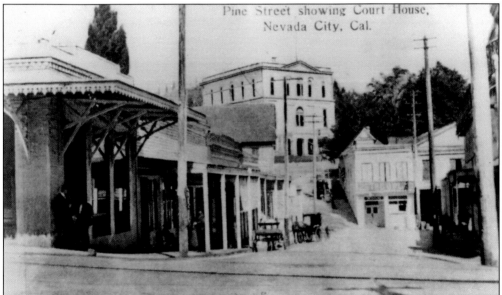

This popular postcard shows the courthouse at the top of the hill and the intersection of Pine and Broad Streets in the foreground. This intersection has always been a prime location for businesses, especially once Broad Street became Nevada City's main street. The building where the men are standing in the foreground at left would become the lot that would house the future Bank of America. (Courtesy of Searls Library.)

On the corner of Main and Commercial Streets, the brick building P. J. Espenscheid constructed was completed in December 1853, on the same site that the first hotel in Nevada was built in the spring of 1850. Espenscheid came to Nevada City in 1851 and built up a successful business. Sadly, the well-respected businessman committed suicide right before Christmas 1857 in Sacramento, "having been laboring under depression of spirits for several months." (Courtesy of Searls Library.)

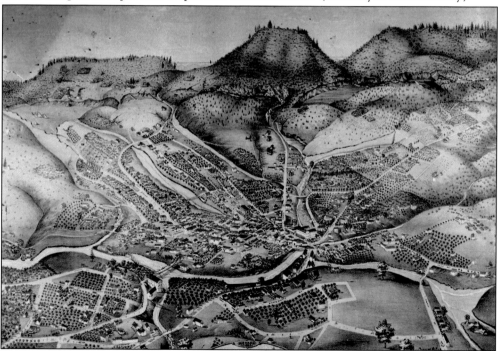

This 1870s bird's-eye view of Nevada City's seven hills is built on shows Sugar Loaf Mountain (center, above), still a prominent landmark above town. This illustration has been reproduced and can be purchased today. Most apparent is the lack of trees surrounding Nevada City compared to the forests that surround the city today. (Courtesy of Searls Library.)

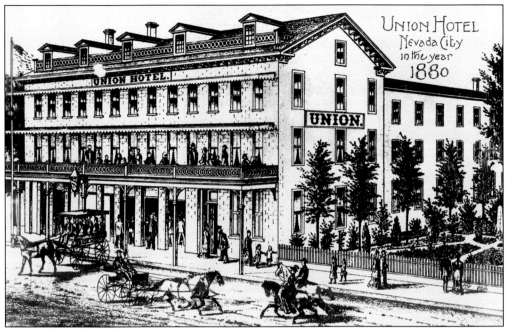

The modern and popular Union Hotel, built in 1863 on Main Street, is depicted in the 1880 *History of Nevada County* and on this postcard. The Union, as pictured, was at its zenith, showing the magnificent three-story structure. The third floor and much of its elegance were consumed by a February 1900 fire. (Courtesy of Searls Library.)

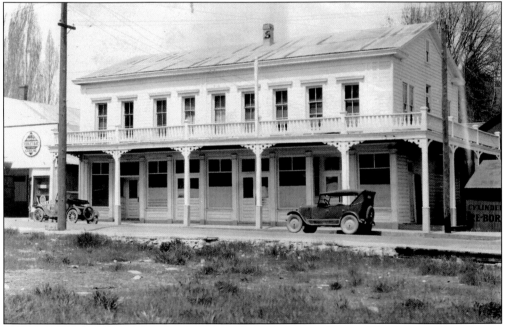

Rebuilt and remodeled after the 1900 fire, the scaled-down Union Hotel rose with only two stories. Once one of the most elegant hotels in Northern California, it began its slow decline after the fire. It ceased operation in 1949, and was later torn down to make highway improvements. (Courtesy of Searls Library.)

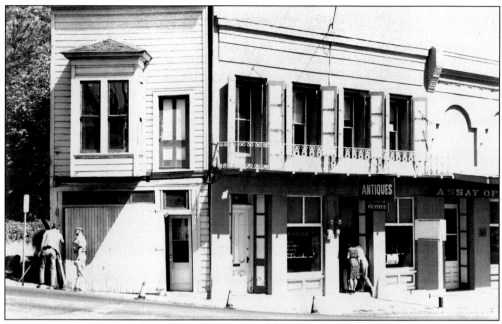

Said to be two of the most historic buildings in California and the West, Ott's Assay Office and the South Yuba Canal Office (pictured at center as an antique shop) are all that is left of Nevada City's original first street. The South Yuba Canal Office (SYCO) served as headquarters for the largest network of water flumes and ditches in California. In 1861, the original ditch, dating back to 1851, and the SYCO occupied this building. The small building on the left was removed many years ago. (Courtesy of Searls Library.)

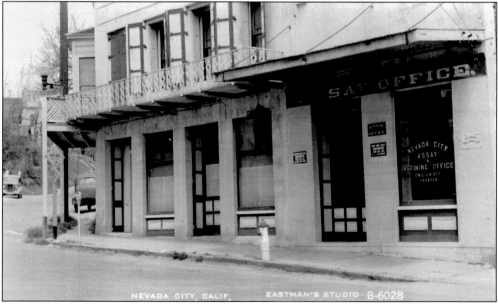

James Ott's original office was built of wood and burned in the 1863 fire. Ott relocated his office to the building next door. Ott was world famous for assaying the samples brought from the Comstock Lode. Confirmation of its silver and gold content led to the 1859 silver rush. (Courtesy of Max Roberts.)

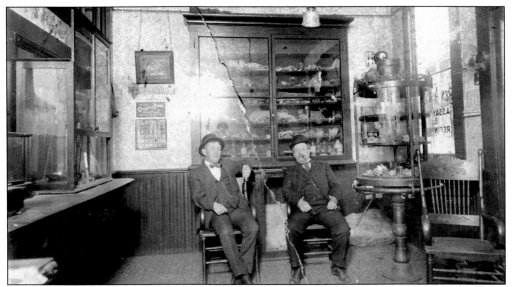

The inside view of Ott's office shows Ott seated on the right. After the Ott family received the letter from New Helvetia, Upper California, Mexico, the course of his life was changed. He decided to accompany Mrs. Sutter to California and was joined by his brother Emil and Charles Dunz, a friend Ott had gone to college with. (Courtesy of Searls Library.)

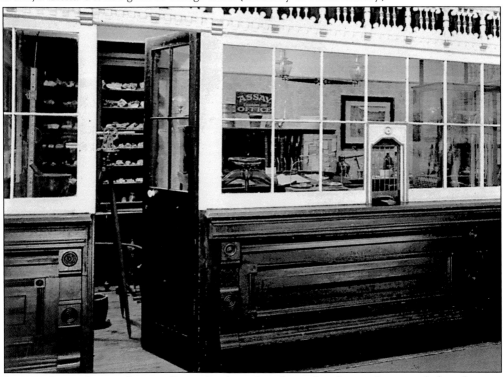

In 1829, James Ott was born in Switzerland to a long line of professional men including doctors, chemists, clergymen, and merchants. By the time he was 21, he was a competent chemist and metallurgist. He was pursuing medical studies in 1847 when a letter arrived from his cousin Johann August Sutter in Sutter's Fort, causing Ott to join the gold rush. (Courtesy of Searls Library.)

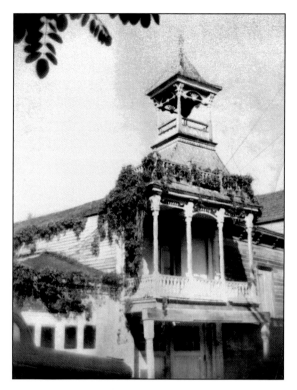

Firehouse No. 1 on Main Street is currently home to the Nevada County Historical Society's Firehouse Museum in downtown Nevada City. Nevada Hose Company No. 1, organized June 12, 1860, occupied this building from May 30, 1861, to 1938. This unique photo shows the "ivy period" when many buildings in town were adorned with crawling green vine. (Courtesy of Searls Library.)

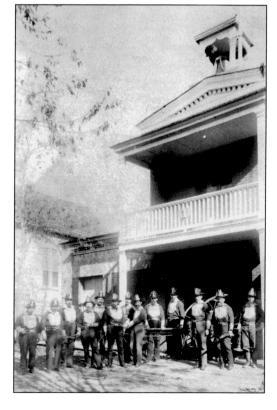

In this photograph, firemen are posing with the hose wagon at Eureka Hose Company No. 2, which is still standing on Broad Street. It would take five fires sweeping through town before the citizens of Nevada City organized a permanent fire department. The past efforts to organize were halted by a feud between two groups of businessmen, the "Main Streeters" and the "Broadstreeters," a bitter rivalry that developed because of jealousy of one section of town threatening to outstrip the other in importance. (Courtesy of Searls Library.)

The Eureka House Company No. 2 was formed by the Broadstreeters on June 13, 1860, one day behind the Main Streeters. A third company was organized on June 23, 1860. Named the Protection Hook and Ladder Company No. 1, it had a short life. The equipment was sold and the members joined the other companies. (Courtesy of Searls Library.)

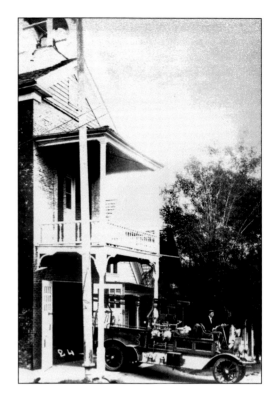

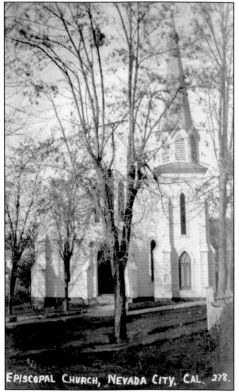

EPISCOPAL CHURCH, NEVADA CITY, CAL. 278.

In 1855, Trinity Episcopal Church was first organized and met in the courthouse for services. The first church was erected on Nevada Street near the spot where Caldwell's Upper Store had been located. Unfortunately, the year was 1863 and the first church was destroyed in the fire that burned most of the town. This photograph shows the new building, erected and opened for service on November 2, 1873. In 1899, the chancel extension was added. (Courtesy of Ruth Chesney.)

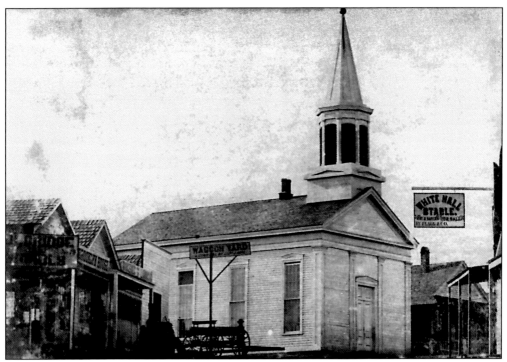

The first Methodist church came to be in 1850 when a house was built for worship. In 1852, it was moved to a lot on Broad Street, and was enlarged in 1853. That building was destroyed in the 1856 fire. Another church was erected, but burned in the 1863 fire. The photograph above shows the church built after the 1856 fire and destroyed in 1863. (Courtesy of Searls Library.)

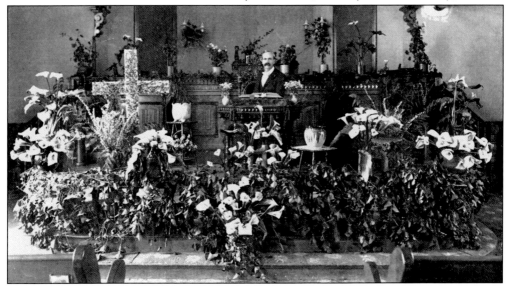

At a dedication on April, 4, 1875, this photograph shows the remodeled interior of the Methodist church—a rare treat, as few photographs are found showing the interior of any church in Nevada City. Though there is no known photograph of the building on Pine Street, Nevada City also had a church near the public school that served a small congregation of African Americans. (Courtesy of Searls Library.)

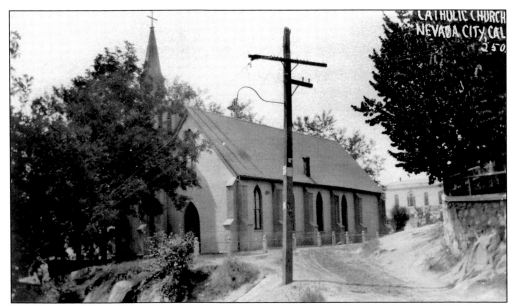

In October 1851, Rev. John Shanahan bought a lot on Main Street between Court and Washington Streets. It was the first deed to be recorded in the recorder's office and the only one recorded in 1851. The first two church buildings burned. The present brick church was built in 1864 and named St. Canice by Father Griffin, after a cathedral of the same name in his native county of Kilkenny, Ireland. (Courtesy of Searls Library.)

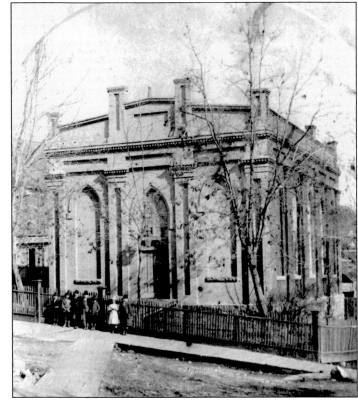

The Congregational Church was built of brick in 1857 to withstand any subsequent fires. The congregation died out, but the church building withstood the next major fire in 1863, when most of the town was destroyed. There is a wooden walk along the street extending in front of the church. The church was later converted to the Church Apartments. (Courtesy of Searls Library.)

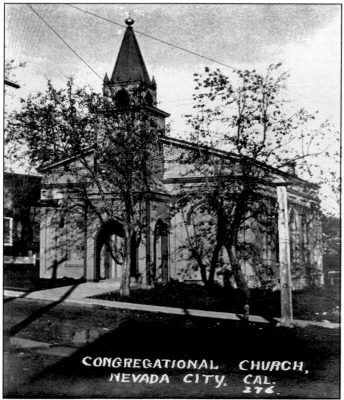

CONGREGATIONAL CHURCH,
NEVADA CITY. CAL.
276.

Quite different from the previous photograph of the Congregational church, this building was purchased by the Baptist congregation in 1955. At one time, the building was remodeled as apartments, but it was converted back to a church and became the First Baptist Church of Nevada City, still used for worship today. (Courtesy of Ruth Chesney.)

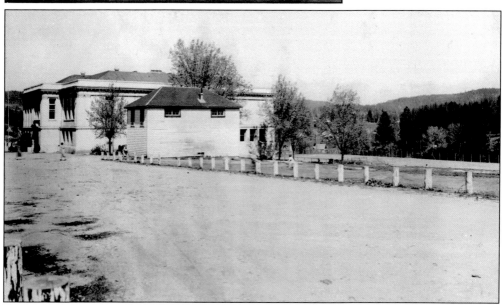

A new high school was not built until after a bond was passed on April 25, 1911, due to much pressure from the public, including a march by the students called the "Grande Boost parade." The school opened on September 12, 1912, although it was not yet complete. A lot had been purchased on Zion Street, and the large building construction had many delays. This is Nevada City High School before the large gym was added in 1936 to the back. (Courtesy of Searls Library.)

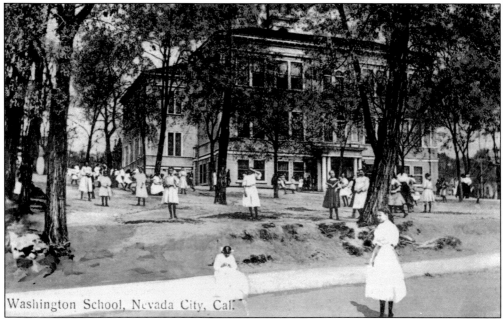

Washington School, Nevada City, Cal.

In 1853, public education began in Nevada City. The 1856 fire destroyed the first schoolhouse, so a second building was used at School and North Pine Streets. At that time, students desiring a higher education were tutored by a schoolmaster after school or in the evenings. Washington School, pictured here, was built on the corner of Main and Cottage and dedicated on Washington's birthday in 1869. (Courtesy of Searls Library.)

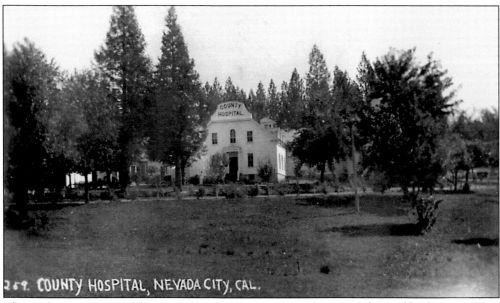

259. COUNTY HOSPITAL, NEVADA CITY, CAL.

This early 1877 view is of the County Hospital, situated on 15 acres on the road leading to Willow Valley. In October 1854, Doctors Alban and Hunt were appointed by the court of sessions as physicians of County Hospital, with funds provided by the state. Prior to that time, those who were destitute or down on their luck had to rely upon public charity. (Courtesy of Searls Library.)

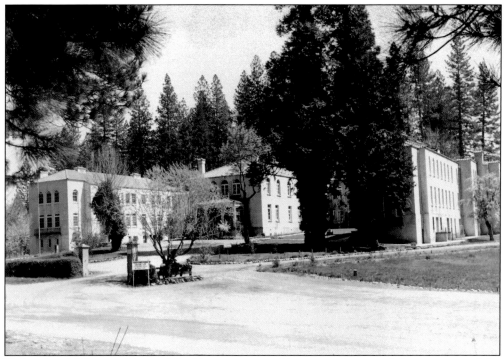

Today the old County Hospital Buildings serve as office space for several departments of the County of Nevada. (Courtesy of Searls Library.)

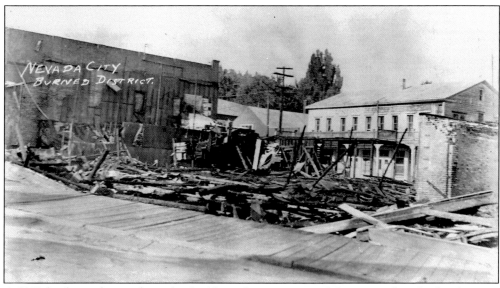

A 1922 fire burned several wooden buildings, but was stopped from spreading further because of the surrounding brick buildings and the firemen's efforts. The plank sidewalk behind the building could easily have helped the fire spread, as in Nevada City's early days. (Courtesy of Searls Library.)

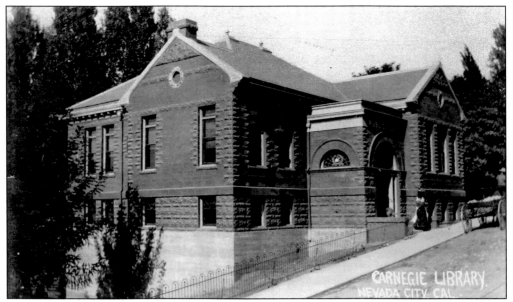

In February 1904, the trustees of the Nevada City Free Library Association received news that Andrew Carnegie had donated $10,000 for a public library building. Bids were opened in 1905, with an estimated completion date in 1906. The San Francisco earthquake changed the plans due to the diversion of building materials and skilled workers to San Francisco to rebuild that city. The library opened in 1907. (Courtesy of Searls Library.)

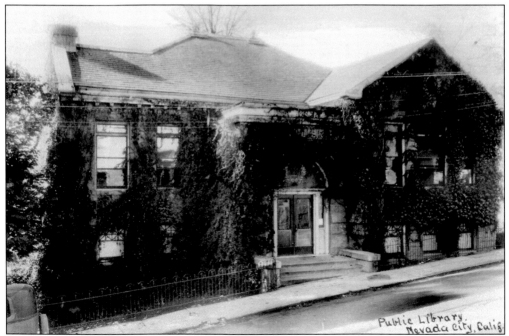

A later frontal view of the Nevada City Public Library shows a good growth of ivy on the building. Houses once stood on the two lots on the corner of Pine and York Streets, where the library now stands, purchased by Frank T. Nilon on July 23, 1904. This building currently houses the history branch of the Nevada County Library System. (Courtesy of Searls Library.)

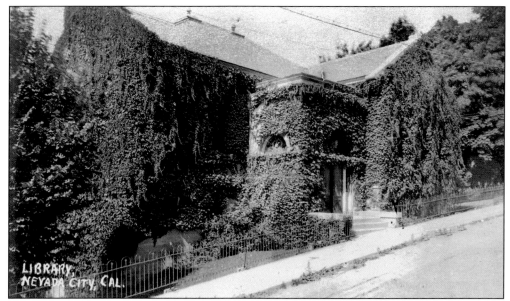

This view of the Nevada City Public Library shows that ivy has all but taken over the front entrance and windows. All three photographs were sold as postcards. Postcards had become popular by the early 1900s and sold at local stores for 1¢ each. By 1908, the United States was third in the world in the sale of postcards, with 799 million manufactured and mailed. Germany and Great Britain were number one and two, respectively. (Courtesy of Searls Library.)

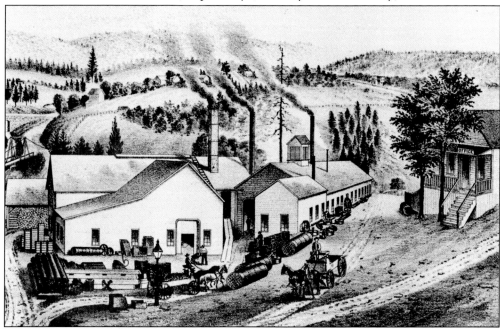

What once had been the Miners Foundry and Supply Company, Nevada Foundry, and Allen's Foundry, by 1859, opened under new owners and a new name—the Miner's Foundry. By 1867, a new building made of granite had been added for a machine and blacksmith shop, 40 by 80 feet long with thick walls two feet wide and a roof of brick mortar and sand covered with a shingle roof. (Courtesy of Searls Library.)

The foundry consists of many rooms. The main room is a very large hall built of stone to prevent fire from destroying the building. This photograph shows an ore car track, old tools, and pieces of iron. One door leads outside, and the other to a shop or casting area. (Courtesy of Searls Library.)

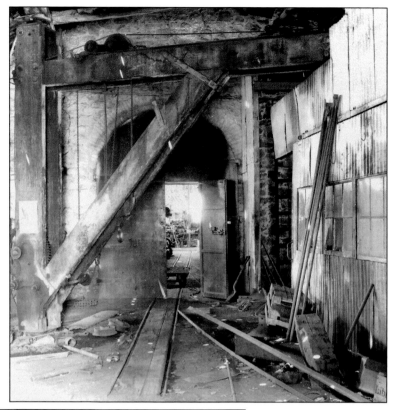

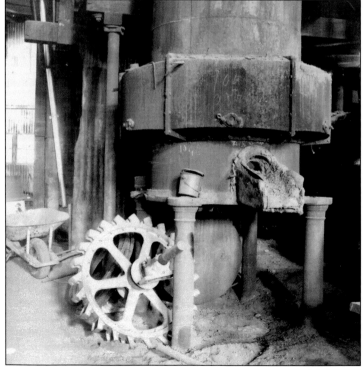

The foundry repaired, manufactured, and sold a variety of equipment, including engines, the famous Cornish Pump, and water gates. They also did custom work for local businesses and mines. In 1879, Lester Pelton of Camptonville came to the foundry with a wooden model of a very large, unusual waterwheel. The first Pelton wheel was manufactured at Allen's Foundry. (Courtesy of Searls Library.)

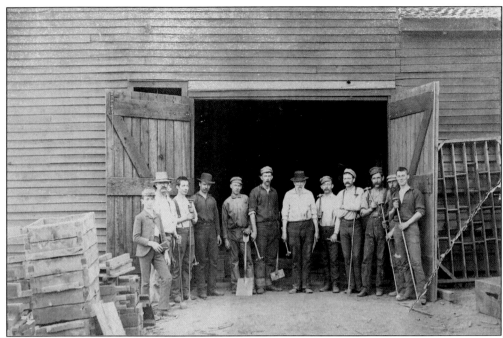

George Allen owned the foundry from 1867 to 1907. The foundry handled orders for ore cars and mine machinery from all over California. In 1900, the Miners' Foundry was awarded the contract to build the new vault for the Nevada County Bank in the National Hotel building. Constructed of steel, the vault was surrounded by brick and cement walls. (Courtesy of Searls Library.)

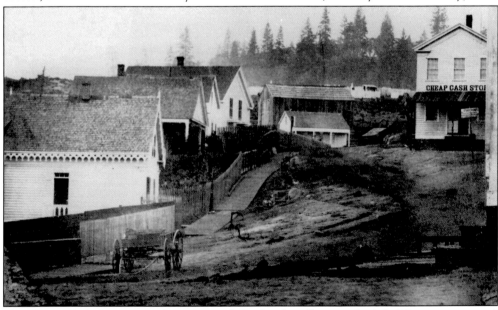

The Cheap Cash Store is on the right, and plank sidewalk is on the left. There were several stores in the early years with "cheap" as part of their name. Cheap John's Auction Store was an early day business located on lower Broad Street next to the National Hotel. Solomon Kohlman advertised the Cheap Store in 1858. This may have been the location of Kohlman's store prior to moving to Broad Street. (Courtesy of Searls Library.)

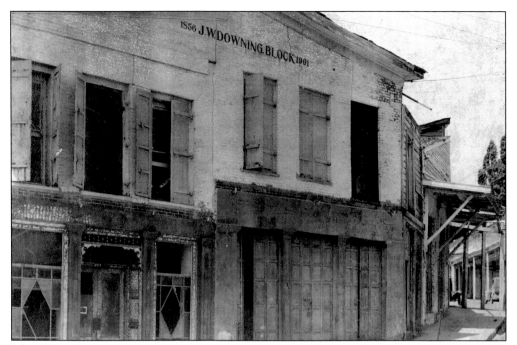

John Walter Downing was one of many immigrants who came to California and became successful. Born in Ireland, he arrived in Nevada City in 1854 to join his brother, Maj. James Downing, who had arrived here two years earlier. John became one of the leading merchants of the city, a tailor by trade. He constructed this building in 1856 on the corner of Main and Union Alley. (Courtesy of Searls Library.)

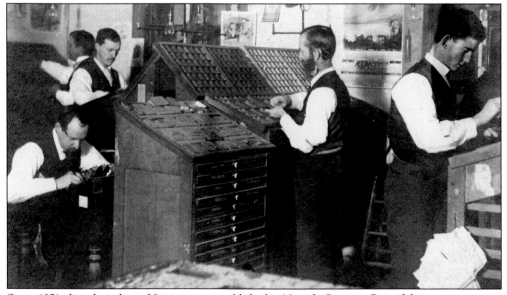

Since 1851, there have been 28 newspapers published in Nevada County. One of the most impressive and longest running was the *Nevada Daily Transcript*. In 1860, the first daily newspaper in Nevada County was the *Morning Transcript*, its office in Nevada City. Nat P. Brown, Gen. James Allen, John P. Skelton, and A. Casamayou were partners with the editor, Allen. In 1861, Brown became sole owner and editor. (Courtesy of Searls Library.)

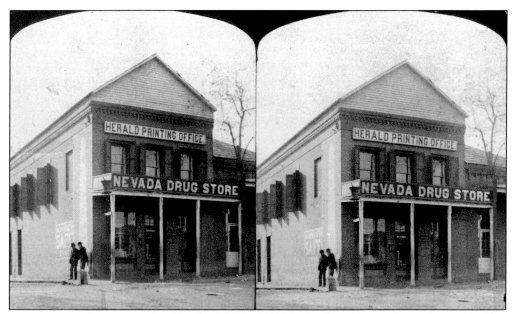

Stereoscopic views were most popular from 1870 to 1910. In local newspapers they were advertised as "Stereoscopic Views of the Queen City of the Sierra Nevadas and Its Surroundings." The *Tri-Weekly Herald* was started in 1878 by Gray, Davis, and Company and became the seventh newspaper to have started in Nevada City. Most of the early newspapers were short lived. (Courtesy of Searls Library.)

Edward and Carrie Arthur pose in front of the old blacksmith shop on Sacramento Street, a short distance up the hill from the brewery. The building to the right is a saloon. The road north intersected with the Plaza, and following the road around the corner into town and heading south, would lead to Grass Valley. (Courtesy of Searls Library.)

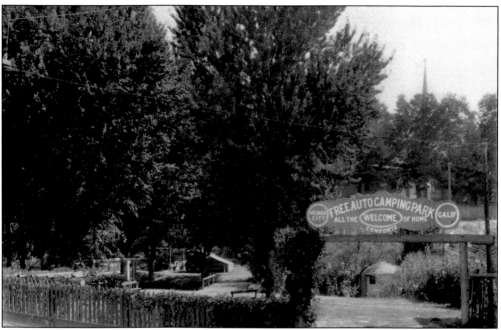

In 1920, the chamber of commerce established a free, overnight auto park on two acres of land on Coyote Street. The park was constructed as an incentive for touring parties to spend one or several nights in Nevada City. This photograph shows the large arch made of cedar at the entrance to the park. A building on the south end of the park was equipped with a shower, changing rooms for men and women, and toilets. (Courtesy of Searls Library.)

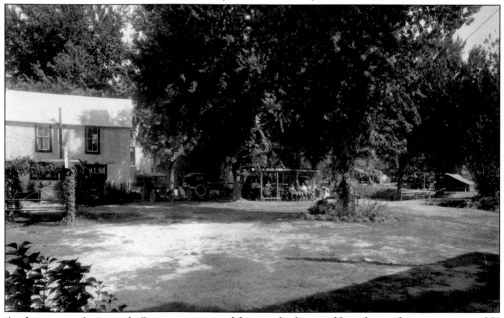

At the auto park, "pergolas" were constructed from cedar logs and boughs, each containing a table and seating. Campers could take refuge in the shade of hop vines and, later, Virginia creepers. An artificial lake, created by putting a dam across the creek, ran through the campgrounds. Two large community kitchens were built with two gas "plates" for cooking. (Courtesy of Searls Library.)

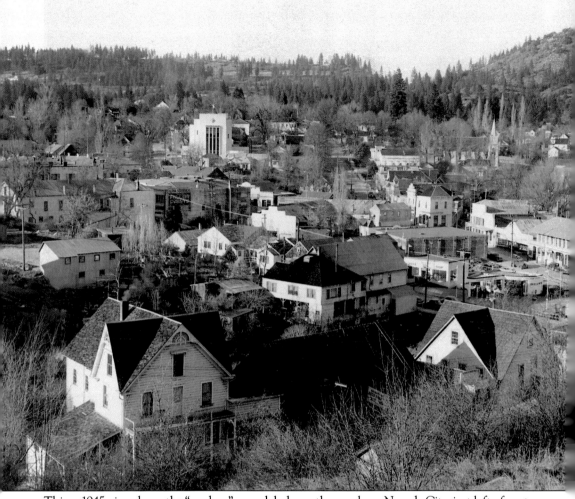

This *c.* 1945 view shows the "modern" remodeled courthouse above Nevada City, just left of center. Main Street is visible to the right of the courthouse. Part of the plaza is also visible on the right. Many of these building would be demolished in less than 20 years to make room for the Golden Center freeway. The new freeway through Nevada City made it possible to develop tourism and made the foothill towns more accessible. Although progress was not accepted by a large number of the residents, it benefited the city a great deal in later years. (Courtesy of Searls Library.)

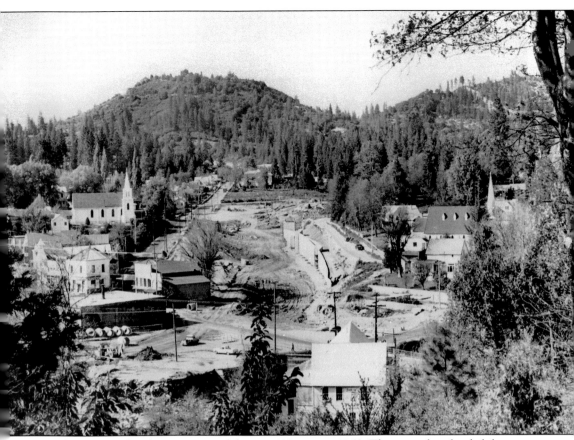

Nevada City faced its hottest topic of the past 100 years in 1963. The issue that divided the city, literally, was the proposed freeway. This aerial view of freeway construction shows Coyote Street left of center, in front of St. Canice Catholic Church. In May, "Plan C," a compromise that saved three historic buildings—the National Hotel Annex, Ott's Assay Office, and the Yuba Canal and Water Company office—was voted on by the Nevada City Council. The proposed highway through Nevada County severely affected Nevada City in the area of the plaza. Construction removed several historical buildings popular with tourists, parking spaces near the business district, and reduced a popular fishing area along Deer Creek. The latter was a favorite fishing hole for local children. (Courtesy of Searls Library.)

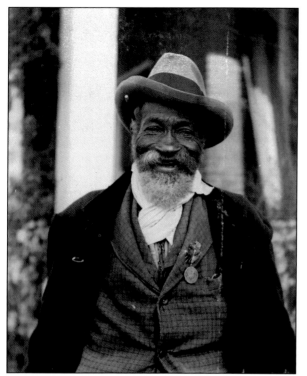

Arriving in Nevada City in 1853, Preston Alexander, one of the early African American pioneers, was well known around town. In the early years, he mined just as most men living in the area did. He married and raised five children in Nevada City. In later years, Alexander was a janitor at the theatre and "city bill poster," as credited in the 1884 advertisement below. Alexander Street was named after him. (Courtesy of Searls Library.)

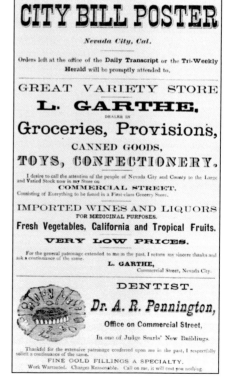

The 1884 *Nevada Daily Transcript Annual*, a special publication that was apparently published each year for customers, included "fifty illustrations on wood," none of which were of local scenes or people. An advertisement at top touts Preston Alexander's services as city bill poster. (Courtesy of Doris Foley Library.)

Four

VIEWS FROM BROAD STREET

For the booming town of Nevada, 1851 would be a year of growth and many firsts, including the opening of the post office, school, dramatic hall, theatre, and Wells Fargo and Company.

Best remembered was the first of many fires. The blaze started in a saloon on Main Street on March 11 and quickly spread to the closely packed shake-and-board buildings and canvas structures. It quickly consumed quantities of blasting powder stored in some of the buildings, as explosions and missiles quickly spread the fire in every direction, including up into the many pine trees standing in the city streets. After the fire, brick buildings were constructed as the townspeople realized the need to prevent future disasters.

In April, the citizens petitioned the state legislature for incorporation and, hearing a report that it was passed, held an election. Many officials were elected, and salaries were so exorbitant that, by September, the city was bankrupt and all city employees were discharged.

During the same month, the second legislature met and passed an act to realign existing county boundaries. Nevada County was created from a portion of the once very large Yuba County and the town of Nevada became its county seat. That certainly warranted a newspaper, and so *The Nevada Journal* was started in the same month, the second newspaper published in the mines.

Broad Street intersected with Main Street, and was fast becoming the most important thoroughfare in the business district. The intersection of Broad and Pine Streets would later become the most significant corner in town.

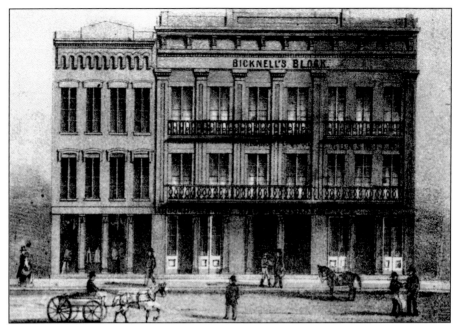

In October 1855, several brick buildings were going up in Nevada City. Among them was the brick block being built by Davis, Bicknell, Thomas, and Young. The stylized drawing above shows the three-story building that towered above the city. It would be one of the few buildings to withstand the 1856 fire. (Courtesy of Searls Library.)

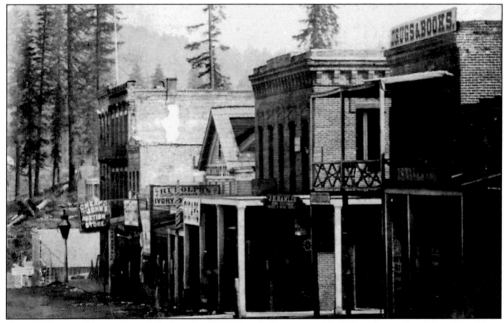

An 1857 view of lower Broad shows the U.S. Hotel, the second building from the right. The Gray brothers came to California from Rutherford County, Virginia, along with companions in 1852. Two brothers would die and only one would return home. Arthur Gray purchased the lot and "house" known as the U.S. Hotel in March of 1856 for $6,000, with $3,000 in cash down and $3,000 due in six months. (Courtesy of Searls Library.)

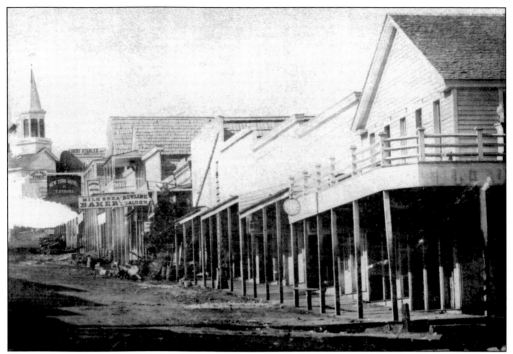

This early photograph taken in 1857 shows wooden sidewalks and a dirt street on the north side of Broad Street above Pine Street. Today only two streets still have wooden sidewalks. The short wooden sidewalk behind the courthouse on Washington Street was replaced in 2003, and an old wooden sidewalk remains on the west side of Main Street above the Nevada City Elementary School. (Courtesy of Searls Library.)

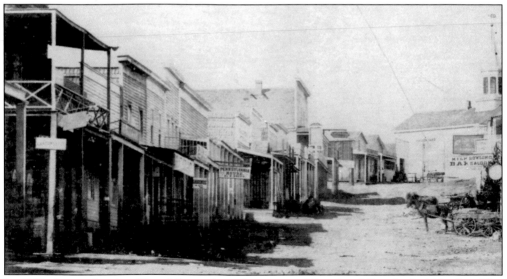

In 1857, the south side of Broad Street from the corner of Broad and Pine looked like this. The Methodist church at the top of Broad appears to have a saloon sign painted on its side, but it is actually hanging from a business on the north side of the street. This early saloon advertised that it had a bowling alley. The Nevada City Drug and Bookstore is the building at near left. (Courtesy of Searls Library.)

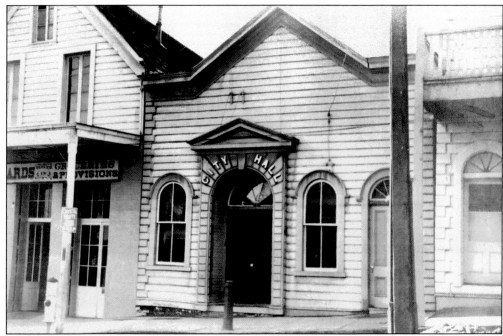

Built in 1878 on Broad Street, the former city hall was torn down in 1935 by Works Progress Administration (WPA) workers. Native son Harry Englebright, serving in Congress at the time, helped to obtain WPA approval for funding of a new and more modern building. The telephone pole on the right is square and a hitching post stands on the sidewalk. (Courtesy of Searls Library.)

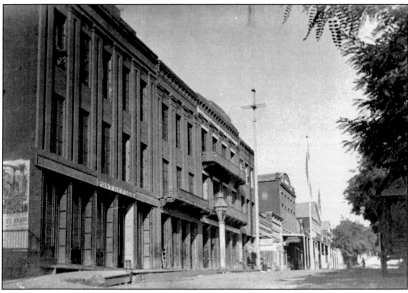

This hotel was one of two brick buildings the 1856 fire did not burn, but neither building escaped the 1863 fire. The damage was so extensive that the *Grass Valley National* wrote, "Nearly all the buildings, including the Bailey House and the National Exchange, two of the largest hotels in the county are destroyed. All the furnishings were destroyed and the walls were said to be in 'only middling condition.' " The National Exchange did not reopen again until April 4 of the following year. (Courtesy of Searls Library.)

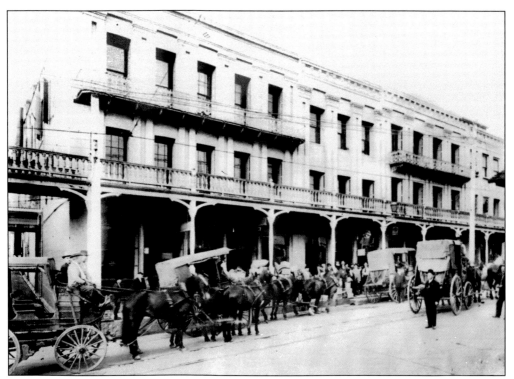

A balcony was added on to the second story of the National Hotel by March 1894, when a new woodcut photograph showing the hotel with the second-story balcony was published in local newspapers. (Courtesy of Searls Library.)

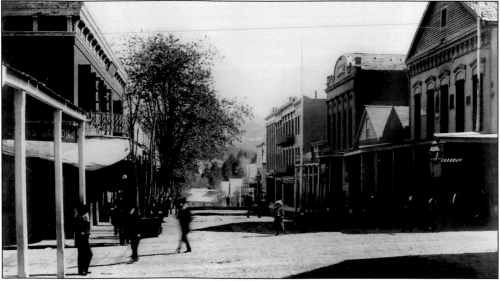

In November 1853, a charter was issued for the second IOOF in Nevada City. The first Odd Fellows hall had been destroyed in 1863. The name chosen for the new order was Oustomah Lodge No. 16. The present building, pictured at center right, was erected in 1872 after the fellowship purchased a lot with an existing one-story brick building. It was torn down, and a new two-story building was built. (Courtesy of Searls Library.)

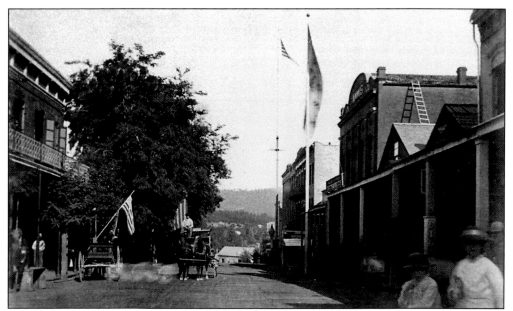

On January 20, 1874, a flagpole was installed in the front of the National Hotel. The trees lining Broad Street across the street from the IOOF Hall are much larger than the previous photo and are long-since gone. In 1861, a wooden flagpole had been erected, but it probably burned in the 1863 fire. (Courtesy of Searls Library.)

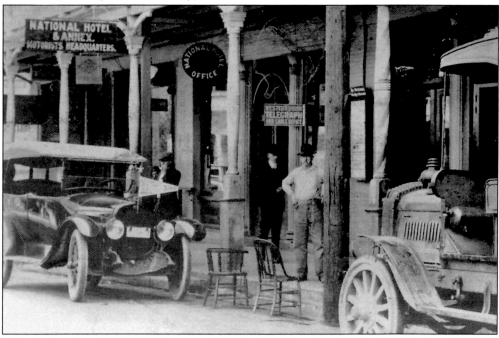

The sign hanging in front of the National Hotel says "Motorists Headquarters." Early automobiles are parked in front of the hotel. The National Hotel can probably still claim to be the oldest hotel in California—even after closing for awhile due to the 1863 fire. The National Hotel annex had been added. This photograph shows the National Hotel office on the ground floor. It also housed the Western Union Telegraph Office. (Courtesy of Searls Library.)

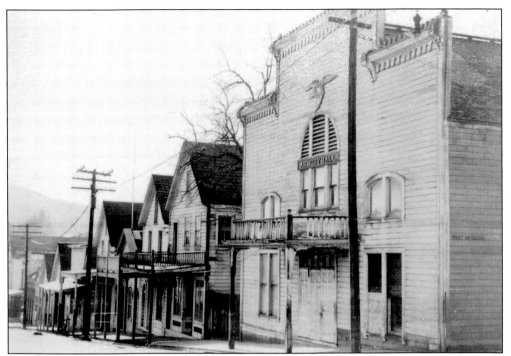

In 1934, Nevada City firemen purchased the Armory Hall to save it from being remodeled into a store and office. It was formally known as Hunt's Hall, after Dr. Hunt, who at one time owned the property. It was demolished in May 1940 to build the modern Purity Store, now Bonanza Market. (Courtesy of Searls Library.)

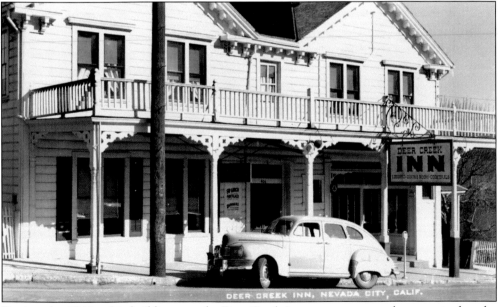

During the 1940s, this building was the Deer Creek Inn, more commonly recognized as the New York Hotel on Broad Street. Over the years, the building changed hands many times, but the original name, the New York Hotel, is how the hotel is now known. Two previous New York Hotels burned in the 1856 and 1863 fires. (Courtesy of Max Roberts.)

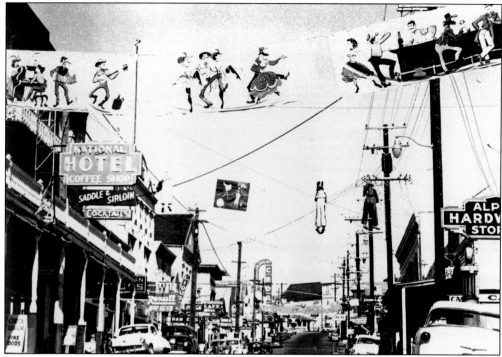

In the 1950s, Broad Street was busy, as evidenced by the many signs hanging above or on business fronts. The Alpha Hardware store on the right celebrated their 100th anniversary in 1978. Their yearly calendars were much sought after by customers, and even more so today. The Nevada Theatre was the Cedar movie theatre during the 1950s. A banner hung across the street advertised a Fourth of July parade. (Courtesy of Searls Library.)

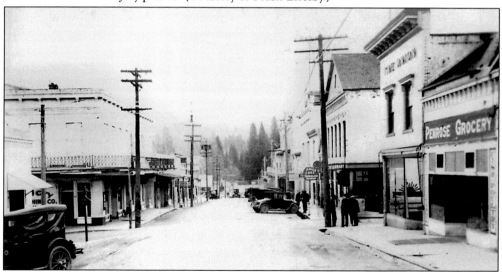

The Penrose Grocery was located just above Pine Street next to the Union Hotel on Broad Street. James Penrose operated the grocery store for 36 years. Prior to that, he was a hardware merchant and a meat dealer. Penrose was active in civil and community affairs: he was on the city council, served as a Nevada City volunteer fireman for 57 years, and in 1931, he was fire chief. (Courtesy of Searls Library.)

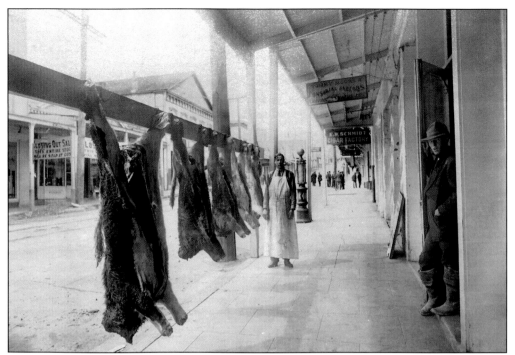

The National Meat Market was on Broad Street across from the National Hotel. Christian Jacob Naffziger was a butcher and owned the meat market in 1890s. He carried "stall-fed beef, fattened mutton, and selected corn-fed pork," that ranged in size from the "little wee pig who couldn't get over the barn door to the big pig who wouldn't." Two doors down was the Schmidt Cigar Factory. In 1875, Naffziger purchased the Union Hotel. (Courtesy of Searls Library.)

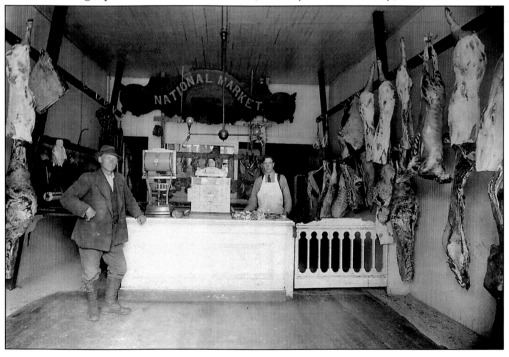

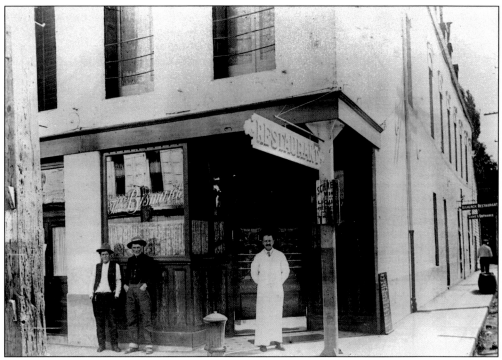

In 1911, Ernest Schreiber purchased the building at the corner of Broad and Pine Streets, then called Britland's Corner. In 1915, it became the Bismarck. On Sundays, people came from Grass Valley by the dozens to eat the 25¢, six-course dinner served there, and it was all you could eat. The name was later changed to Schreiber's Restaurant and Bar, and the corner became known as Schreiber's Corner. (Courtesy of Searls Library.)

Pacific Gas and Electric (PG&E) had an office on Broad Street for many years. At a civic affair in San Francisco at the old Palace Hotel, John J. Jackson, a Nevada City resident and businessman, claimed that PG&E got its start in Nevada City at the National Hotel-apparently at a 2:00 a.m. meeting between Colgate; Romulus Riggs, grandson of Colgate; John Martin; and Eugene DeSalba, who were meeting at the hotel to discuss other business. (Courtesy of Searls Library.)

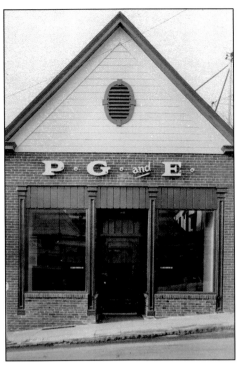

California's oldest theatre, the Nevada Theatre, was built by George Pierce and opened in 1865. In 1908, the theatre was remodeled to make the interior more up-to-date. Famous entertainers of the day appeared there while it operated as a playhouse. It was remodeled again in 1915, and underwent extensive renovation in 1948. It continued to operate as a movie theatre until 1958, when it closed. In the 1960s, it was rescued by the Liberal Arts Commission. (Courtesy of Searls Library.)

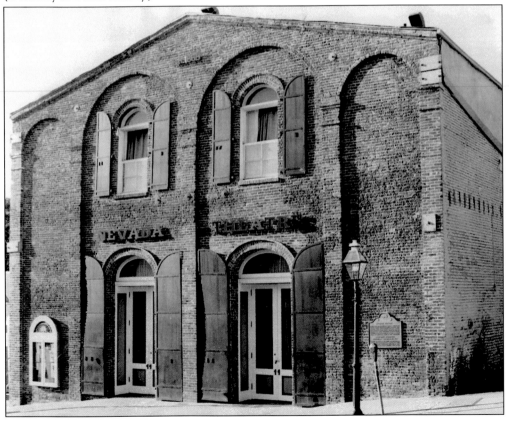

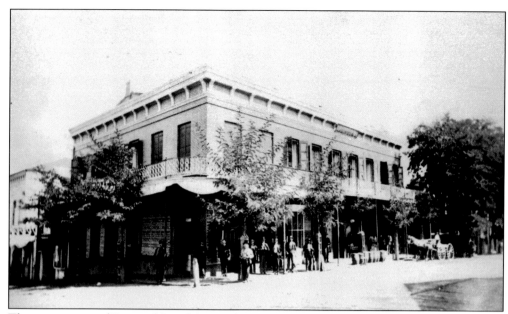

The intersection of Pine and Broad Streets became an important corner after Main Street was replaced as the main thoroughfare in town. Standing in front of the Kidd and Knox building, from left to right, are Rev. J. Sims, Red Seimer, W. J. Britland, J. T. Morgan, Delos Calkins, J. Flemming, Charles Ashbourne, Tom Stewart, H. C. Miles, J. Ralphe, George M. Hughes, J. Colley, George Jacobs, D. Baker, ? Lutze, and A. H. Morgan. (Courtesy of Searls Library.)

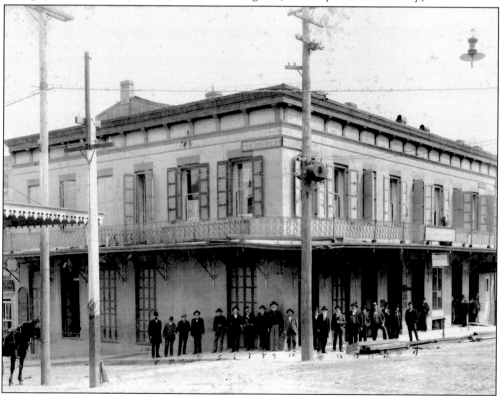

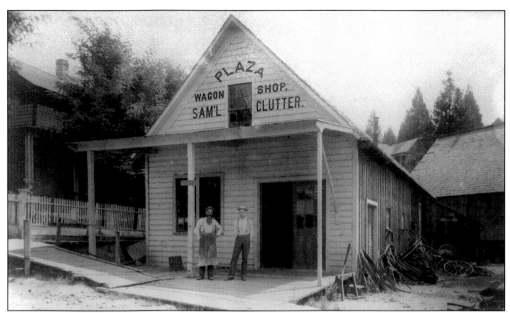

An earlier photograph of Samuel Clutter, left, and his shop is shown here. The sidewalk is still planked. In 1914, a cement sidewalk was "layed" in front of the livery stable and theatre. Property owners were responsible for having the property in front of their businesses paved. (Courtesy of Searls Library.)

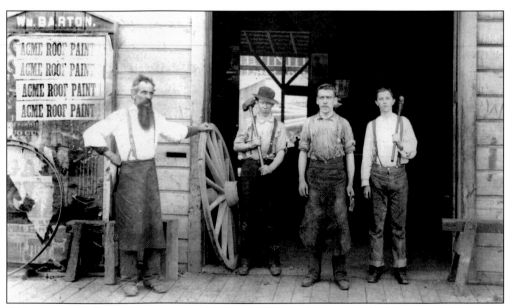

Old wagon wheels rest against Samuel Clutter's Wagon Shop. Samuel Clutter, an early pioneer, was a town trustee from 1872 to 1874 and city treasurer in 1910. In 1866, Clutter was one of the organizing members of the Independent Order of Good Templers, Nevada Lodge No. 201 and was active in the local Independent Order of Odd Fellows, Oustomah Lodge. Clutter is on the left. (Courtesy of Searls Library.)

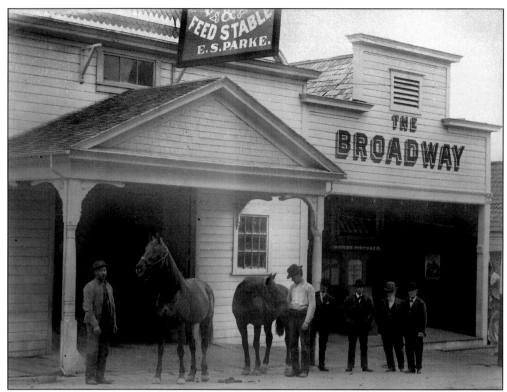

About 1910, two men in working clothes and four gents in suits pose with horses on Broad Street. Edward Parke was the proprietor of the National Exchange Stables at 210 Broad Street, across from the National Hotel. Parke also rented carriages for weddings and parties. The Broadway Theater was at 208 Broad Street to the right of stable. (Courtesy of Searls Library.)

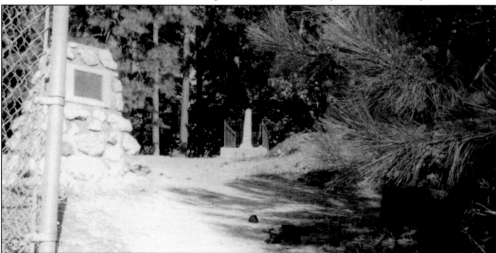

Pioneer Cemetery is located on a hill at the top of West Broad Street and is recognized as the first cemetery in Nevada City. Established in 1851, it sat behind the first Methodist church. A very small number of the graves have markers that remain or are legible. Many early markers were wooden and have been worn by time, damaged by man or nature. There are probably as many as 400 unmarked graves. (Author's collection.)

In Pioneer Cemetery, a monument remembers Henry Meredith, who died in an ambush by the Paiute Indians at Pyramid Lake, Nevada, Utah Territory on May 12, 1860. His body was returned home to Nevada City, and his funeral was one of the saddest days in the history of the town. The church was so crowed that hundreds were not even able to enter. (Author's collection.)

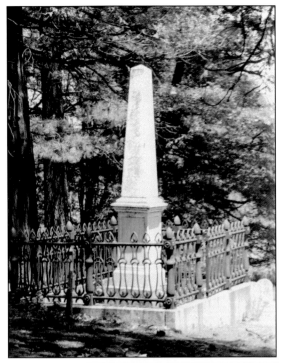

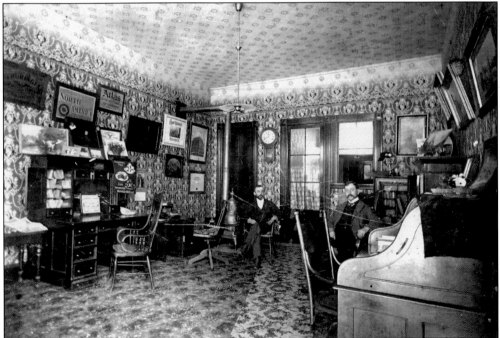

This view shows the Victorian office of Edward J. Morgan, son of John Morgan. After graduating from Nevada City High School in 1891, Morgan attended school in San Francisco. Returning to Nevada City, he was employed for a time at Citizens Bank. Later he was the manager of the Nevada City Water Works, and in the insurance business he represented many companies from his Broad Street office. (Courtesy of Ruth Chesney.)

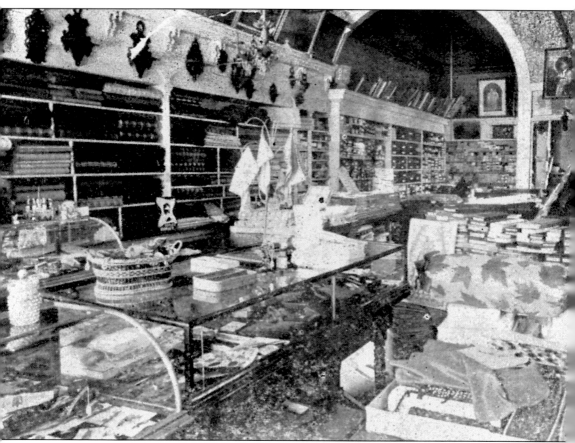

The very successful dry goods store of Mrs. Cleora A. Lester and Margaret (Thomas) Crawford carried the most extensive selection of trimmed hats and bonnets in Nevada City, and was most popular with the ladies. Specialty goods were carried seasonally. This photograph shows the extensive stock carried in their Broad Street store. Cleora "Addie" Davis arrived in Nevada City in 1850 with her parents, Sarah and Zeno Philosopher Davis, and married Anson W. Lester on May 5, 1869. Her husband was in the grocery business with Charles E. Mulloy until his death in 1876. Margaret Thomas married W. H. Crawford in Nevada City in 1865. He was in the hardware business for a number of years, as well as agent for Eureka Stage and Express. (Courtesy of Doris Foley Library.)

Five

SNOW SCENES

Although temperatures are moderate most of the year, Nevada City has four seasons and an altitude of 2,500 feet in the Sierra Nevada foothills. Winters of the past were said to be more severe, and Nevada City had much heavier snowfalls than are experienced today. The weather was always a threat to the town and its economy. Heavy rains poured down week after week, sometimes month after month. Roads became impassable to man or beast, as creeks and streams rose and bridges washed out, leaving the young town isolated. On the other hand, too little rain would mean mining operations had to be suspended, for mining in any form needed large amounts of water to recover the gold.

More often than not, it was heavy snow that isolated Nevada City, holding it captive with drifts piled high to the rooftops and no way to clear roads other then shovels and muscles. The winter of 1889–1890 was remembered as one in which no person's feet in Nevada City touched bare ground, and by the end of January, snow on the ground measured 10 to 15 feet on Commercial and Pine Streets. The storm began on December 6, 1889, and a series of storms continued for two months, causing more than half a million dollars in damage in the county. Building after building collapsed in the business district. At that time, the only transportation in and out of town was on snowshoes.

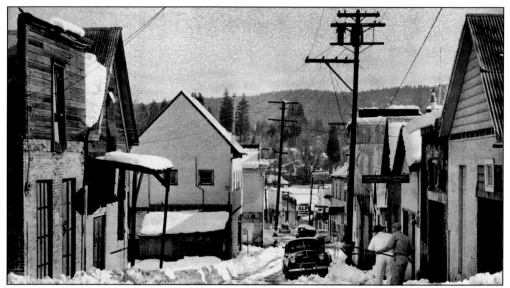

To carry on business as usual, the early day residents of Nevada City would shovel the snow off the sidewalks and into the streets. This photograph shows Commercial Street below York Street in the 1940s. (Courtesy of Wally Hagaman.)

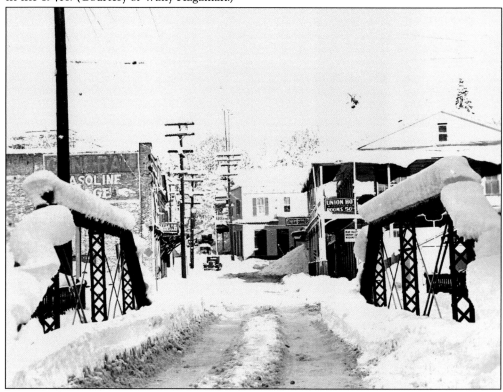

Between the Union Hotel sign, right, and the Main Street bridge, a highway sign indicates the mileage to Bear Valley, Emigrant Gap, and Washington. There were footways on both sides of the steel bridge for foot traffic to the Plaza. For early Nevada City residents, Bear Valley was a favorite spot for camping, fishing, and hunting. (Courtesy of Searls Library.)

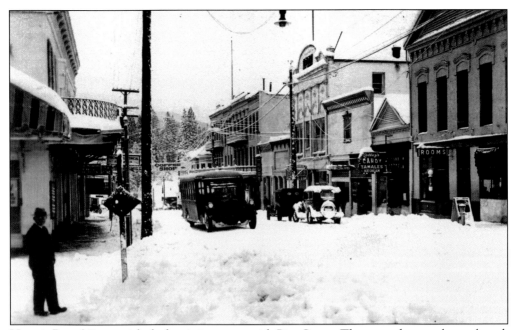

Here is Broad Street right before it intersects with Pine Street. The street has not been plowed, and except for the gentleman in the hat and perhaps two people standing in front of the drug store, there appears to be not much foot traffic. The bus appears to be negotiating the road with a few inches of snow on the street. (Courtesy of Searls Library.)

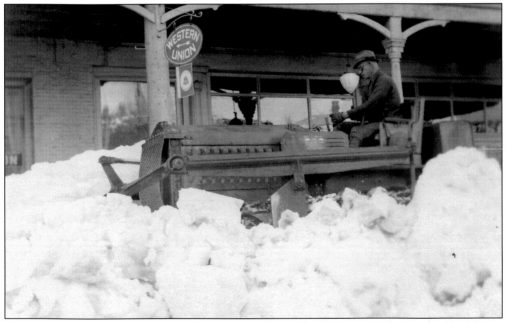

On January 29, 1937, the greatest amount of snow the city had experienced since the "Big Winter of 1889–1890" covered the city. Starting on a Friday afternoon, in a 24-hour period, 18 inches of snow fell. A snow plow is seen here trying to clear the doorway of the Union Hotel on Main Street. Several buildings were reported to have collapsed in the county after the storm due to the weight of the snow. (Courtesy of Searls Library.)

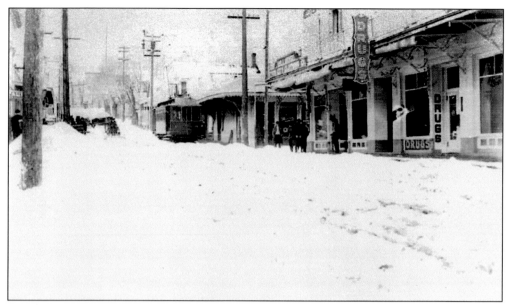

Broad Street is almost completely white in this photograph taken at the turn of the 20th century. Horse-drawn sleighs are left of the trolley. (Courtesy of Searls Library.)

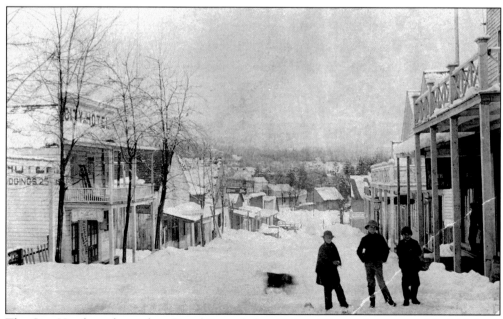

The City Hotel was located on Broad Street below Union Alley and was owned by Irish-born Owen Conway Conlan. On the right is the Scadden Saloon. A January snowstorm in 1895 brought snow as far as Smartsville. By January 21, the snowfall was 41 inches for the season, and a mile from town it was four feet high with drifts of 20 feet. (Courtesy of Searls Library.)

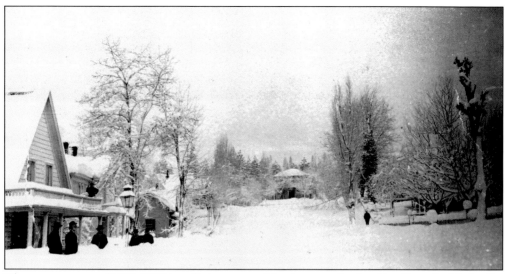

The severe storm of 1889–1890 is well documented in photographs. Looking from the Methodist church up Broad Street, the Mulloy home (522 Broad Street) is visible in the center. It divided Broad Street into East and West Broad Streets. The men are standing in front of 447 Broad Street, next to the house where Ellen and Aaron Sargent once lived. (Courtesy of Searls Library.)

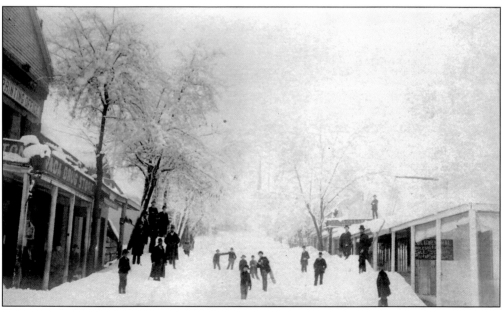

Snow is piled high in the center of Broad Street as residents of Nevada City have scraped it off the roofs to prevent them from caving in under the weight. On the right is Wholesale and Retail Drygoods, a store owned by Abraham Blumenthal. On the left, near the Vinton Nevada Drugstore (one of the oldest drugstores in Northern California) is the *Evening Herald* office. (Courtesy of Searls Library.)

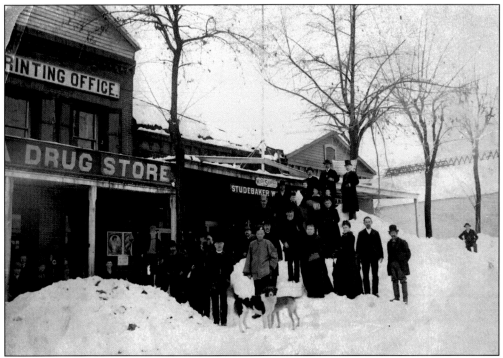

A winter-loving group poses in front of Vinton's Nevada Drug Store and the Studebaker sign on Broad Street. A telephone or fire call box can be seen on the front wall of the drugstore to the left of the white support post. (Courtesy of Searls Library.)

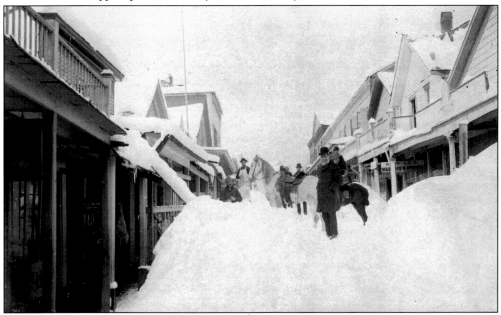

A man shovels snow off the roof of the building just left of center. There appears to be a collapsed roof to the left, which the men, standing in the middle of Commercial Street, are investigating. The sign for Sung Lee Washing and Ironing is hanging behind the horse. (Courtesy of Searls Library.)

Six

Mining, Industry, and Transportation

The miners of 1849–1850 learned that the importance of water was second only to gold itself. Most of the men who came to the goldfields had no mining experience, but learned the techniques quickly. First equipped with pan, pick, and shovel, men invented new and ingenious devices to extract and wash the earth from the gold. As miners expanded their search up into the foothills, and the placer deposits were quickly depleted along the bottoms of creeks, river, and streams, they discovered gold in the quartz rock of the banks and hillsides in and around Nevada City and vicinity.

Although they did not know it at the time, miners had discovered the source of the gold they had been panning in the creeks, rivers, and streams. Hidden from the eyes of man for millions of years, high above the waterways that had first drawn the forty-niners, deep beds of tertiary gravel were found. That discovery meant the end of gold mining as they had known it.

After first being discovered in Nevada City, the streambeds were abandoned as quickly as they had once been populated, and the hillsides were soon swarming with men wielding picks. This would lead to two significant new methods of mining in Nevada City: hydraulic and deep shaft. Other industries and commerce would grow out of need, due to consumption of natural resources used in new mining methods.

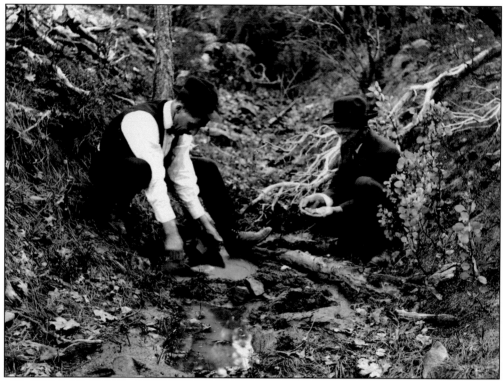

The earliest mining on Deer Creek was placer mining, commonly known as "panning." Early miners were usually clad in attire much less formal than this photograph of Andrew Goring and Charles Graham, trying their luck on this muddy bank. The man on the left is tilting the gold pan, hoping to "see color." (Courtesy of Searls Library.)

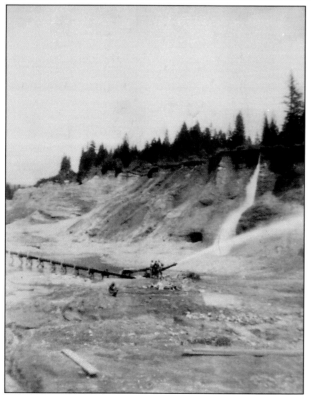

The Ellis Clack Mine in the Nevada City Mining District shows three men directing a "monitor" with the forceful stream of water to blast away dirt and rock on the hillside above. In March 1853, Edward E. Matteson of Nevada City used water pressure on his claim on American Hill from a canvas hose that Chabot, a sailmaker by trade, had constructed for him. Chabot also attached a nozzle to the end. (Courtesy of Searls Library.)

A wooden flume brought water over miles to where the power of the hydraulic nozzle would send thousands of tons of rock, sand, mud, and debris down into the valley. The water and soil were contaminated with chemicals and mine trailings that killed fish and wildlife. In 1884, Judge Lorenzo Sawyer, in federal court in San Francisco, handed down a decision that would end large-scale hydraulic mining. (Courtesy of Searls Library.)

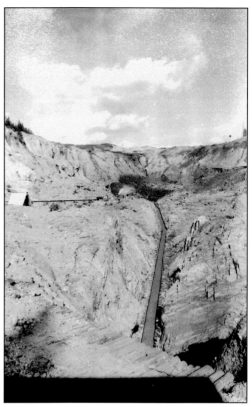

A group of hard-rock miners from the Nevada City Mine are identified on the back of this photograph as, from left to right, (first row) Will Hutchinson, Jason Daniels, P. Whalan, ? Hosking, W. Wilcox, T. Barton, Con Bracelin, John Keenan; (second row) David Hutchison, unidentified, M. Hartman, Mr. Beedle, Jason Thomas, Mrs. Harryhougen, Jason McCradle; (third row) John Dower, Thomas Peard, Martin Thomas, Henry Burst, John Hutchison, Mr. Blake, and John Grimes. There are more names than there are men in the photograph. Standing in center front is David Hutchison, superintendent. (Courtesy of Searls Library.)

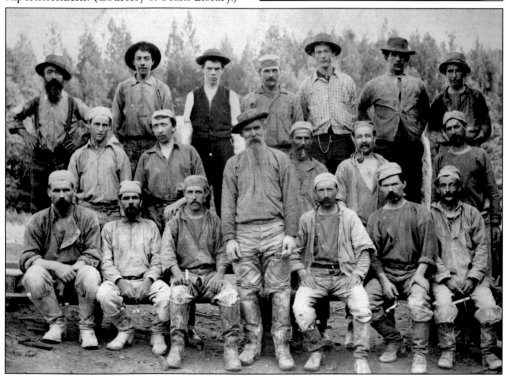

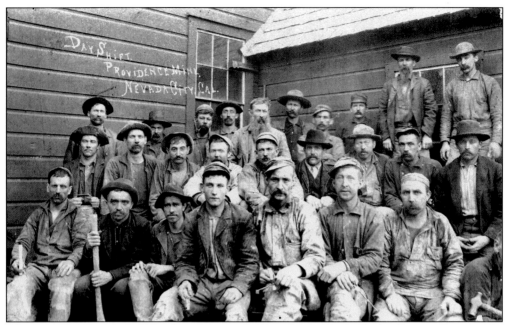

These quartz miners take a break to pose at the Providence Mine, the leading producer in the Nevada City Mining District in 1879 and 1885. The mine was located on Deer Creek and at that time was working a shaft 1,200 feet deep, with 100-foot levels. The pay-rock was hoisted up from each of the 11 levels. (Courtesy of Searls Library.)

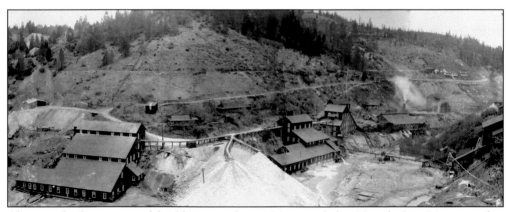

Above is a bird's-eye view of the Champion Quartz Mine just below Nevada City. Money used to buy mining interests flowed into California from all over the world. In October 1895, a French syndicate paid $5,000 down to purchase the Champion Quartz Mine, with the same amount due monthly until January 31, 1896, when the balance of the $1,250,000 option would be due. At the time of the deal, the mine was not on the market and the San Francisco German owners did not want to sell. (Courtesy of Searls Library.)

Down the Providence shaft of the Champion Mine at the 1,000-foot level, the hanging wall was causing trouble. Vast amounts of lumber were used to shore up mile after mile on the many levels of each mine deep under Nevada County. While keeping the lumber dealers in business, the forests were stripped of lumber for miles around in the early years. (Courtesy of Searls Library.)

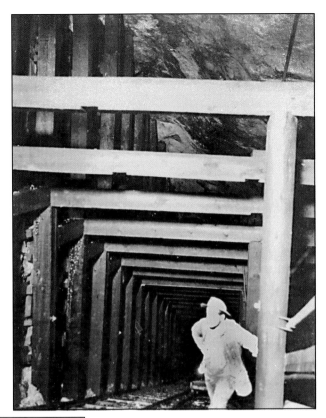

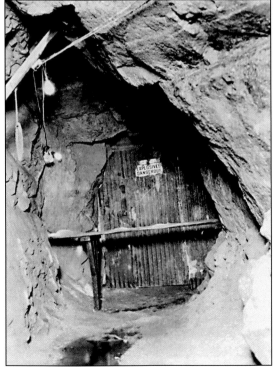

This underground tunnel leads to one of the levels of the Champion Mine. The door with a bar across it kept the stock of explosives secure. Only authorized personnel had access to the stock. Mining was a dangerous occupation and there were many accidents each year that resulted in death or serious injury. (Courtesy of Searls Library.)

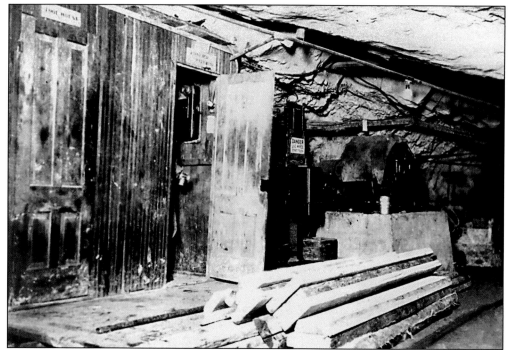

The toolhouse, telephone booth, first-aid cabinet, pump motor, and compressor are seen on the 2,700-foot level of the Providence vein of the Champion Mine. In 1913, a bill passed that all mines operating in California with a depth of more than 500 feet must be equipped with a working telephone at each level. (Courtesy of Searls Library.)

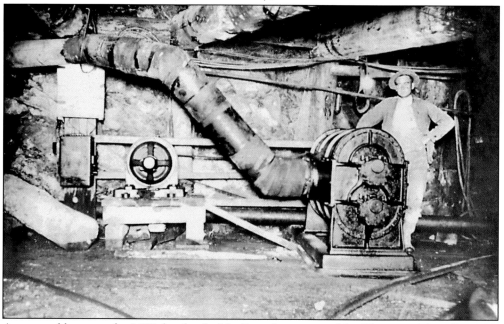

A pressure blower on the 1,600-foot level of the Providence vein of the Champion Mine illustrates the large quantity of equipment and machinery that had to be taken down and installed in the mine's many levels. (Courtesy of Searls Library.)

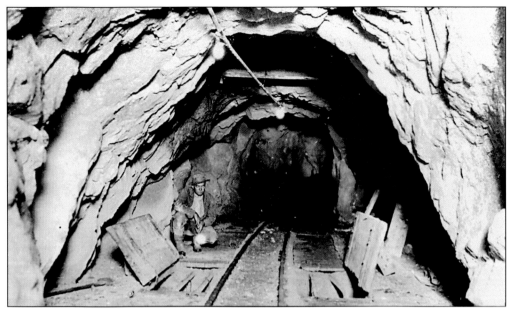

The Providence vein at the Champion Mine shows the chutes into the "skip pocket," where mule trains dump quartz rock at the 2,700-foot level. Mules were often used underground, with some remaining in the tunnels the rest of their lives without ever seeing the light of day again. (Courtesy of Searls Library.)

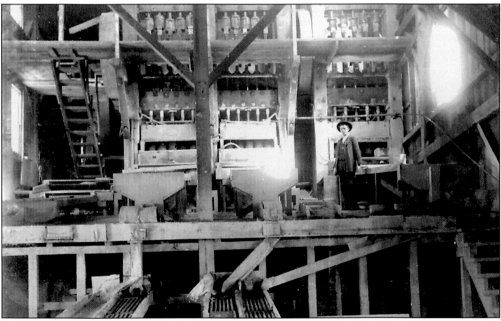

This shows one level and some of the underground workings of the Champion Mine. In 1902, the mine was incorporated with 125,000 shares at $5 each. The Champion Group owned the Champion, Merrifield, Providence, Wyoming, Nevada City, and Spanish Mines. A new plant was to be built at the Merrifield, similar to the one at the Empire in Grass Valley. The Champion property consisted of a consolidation of a number of mines and claims, containing about 440 acres. (Courtesy of Searls Library.)

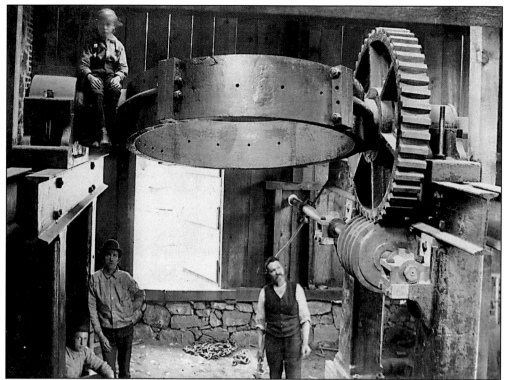

The mines supported the foundry in Nevada City with their need for many large iron machineries and parts. If a machine broke and there was no spare, that section of the mine would have to shut down operations. This caused delay and loss to both the mine owners and the miners until it was up and running again. The loss of money would trickle down and affect the local businesses in Nevada City. (Courtesy of Searls Library.)

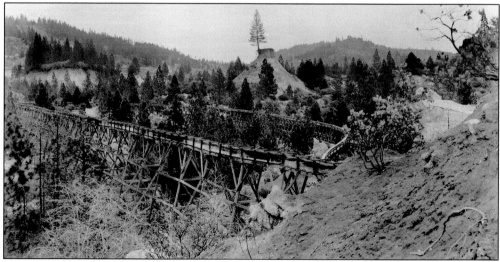

The Hirschman Diggings outside of Nevada City show the wooden flumes that carried water to the mines and into town. In the center is the famous "Lone Pine," a Nevada City landmark for many decades. On January 31, 1911, it was finally blown down by wind from the few feet of soil it clung to. It dropped to the bottom of the diggings. (Courtesy of Searls Library.)

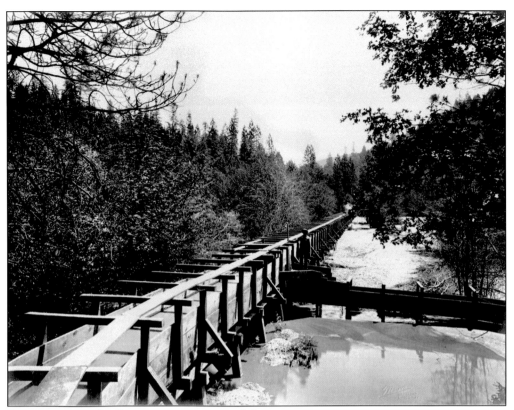

Frozen water in the flumes sometimes caused the mines to shut down. The ice would have to be broken in the flumes by hand so that the water could flow again to the mines and the town. (Courtesy of Searls Library.)

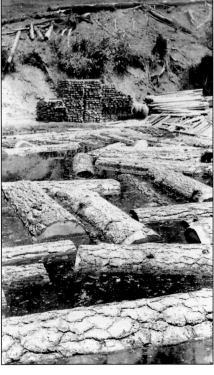

Lumber was another important industry in Nevada City. In 1850, Lewis and Son built the first sawmill. Both water and wagons were used to transport the logs to the lumber mills as the country grew. There were many lumber mills between Nevada City and Truckee. The Marsh brothers and George Cooper had lumber mills adjacent to Nevada City. (Courtesy of Searls Library.)

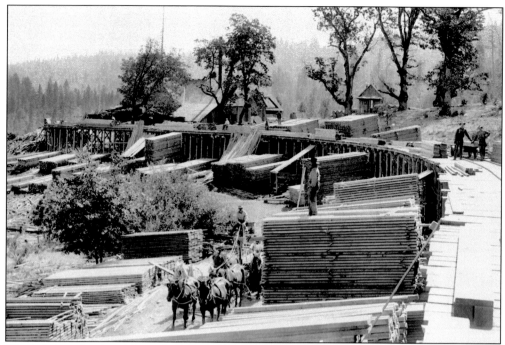

This is believed to be a Martin Luther and Daniel Marsh sawmill at the New York Canyon Mine. In 1885, the Marsh brothers opened a new sawmill at Rock Creek, serving the building and mining industries and keeping a large stock of cut lumber. Louis Voss had a large lumber camp 12 miles east of Nevada City and harvested sugar pine that was shipped to the San Francisco market. (Courtesy of Searls Library.)

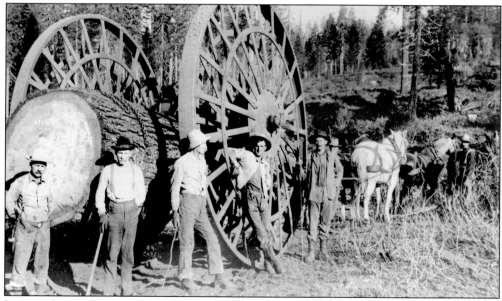

In 1848, logging began in Nevada City. Early lumbering used man, beast, and steam power to move enormous logs cut from the first-growth trees. Pictured is a slip-tongue or big wheel used to move logs to be milled. Early logging and clear-cutting were wasteful, but for over 100 years mining was king. (Courtesy of Searls Library.)

Agriculture would become California's biggest export. Nevada City Frenchman Felix Gillet, a barber turned nurseryman, would become widely known for his Barren Hill Nursery, the development of the filbert nut, and founding the state's walnut industry. He imported trees and plants from his native France by the ton and grew Bonne Bouche strawberries that measured from four to six inches in diameter. (Courtesy of Searls Library.)

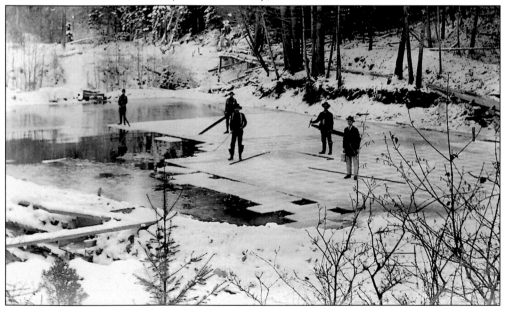

A smaller but important industry for Nevada County was ice harvesting. Ice was not only used for drinks and keeping food cold. It was also sent to the mines in Virginia City, Nevada, to cool the lower levels during the summer. Water already in the mines could reach a temperature of 100 to 130 degrees. Men could not swallow water that was almost boiling. This is Louis Brindefojohn harvesting ice at Rock Creek. (Courtesy of Searls Library.)

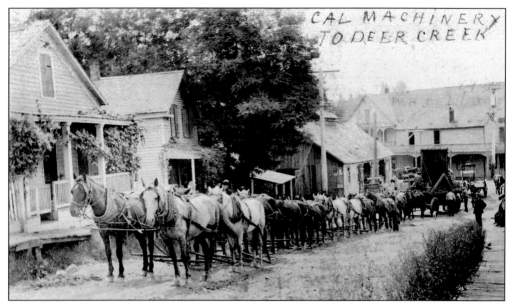

Early transportation relied on horses and mules. Charles Brown and his two sons, Cecil and Harry, were responsible for hauling machinery to the Deer Creek powerhouse in Nevada City. This early hauling crew is stopped on Sacramento Street. (Courtesy of Searls Library.)

In 1913, Bill Chappell crosses Deer Creek with his horse, Boxer, at the Lecompton Mine in Nevada City. In March 1851, an immense storm in Northern California caused a rise in the level of the creek. On March 6, the Broad Street bridge was carried away and in a few hours the theatre, a boardinghouse, and nearby buildings were also swept down the creek. This would later be viewed as a blessing, as it acted as a break to save the town from being destroyed by fire. (Courtesy of Searls Library.)

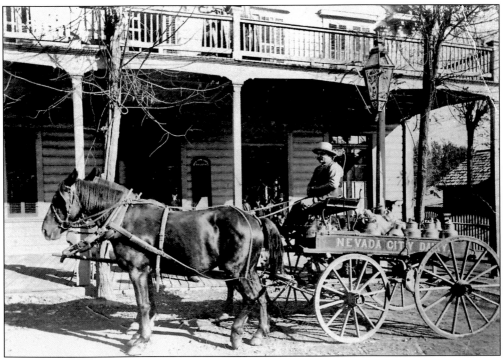

During the 1890s, Joe Ramelli delivers milk in front of the New York Hotel on Broad Street with his lightweight wagon drawn by a pair of horses. (Courtesy of Searls Library.)

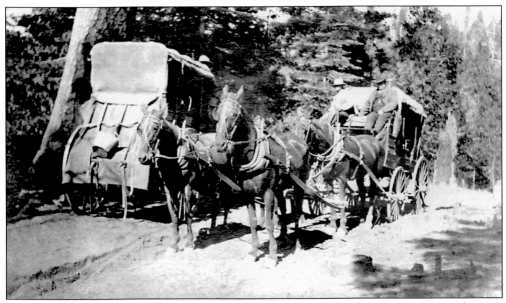

Two stages pass on a road outside Nevada City. The roads were dusty in summer and wet or impassable with snowdrifts in the winter. In March 1850, there was 10 feet of snow on the banks of Deer Creek. Transportation could not get in or out of the town. (Courtesy of Searls Library.)

Runaway horses and buggy accidents were a hazard of the "good old days"—about as commonplace as later automobile mishaps. Drivers sometimes neglected to secure the reins to the hitching post. The last hitching posts in the city were at the National Hotel and in front of Paul Rohing's Barber Shop. In 1932, the barber shop hitching was still standing. (Courtesy of Searls Library.)

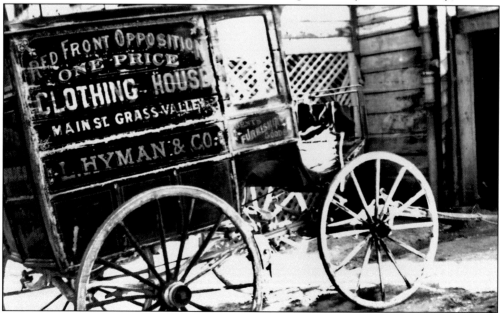

This buggy carried advertising on its sides and back, like this sign for the Red Front Opposition Clothing House and perhaps competitor L. Hyman and Company. They were not so unlike our passenger buses and trucks of today. (Courtesy of Searls Library.)

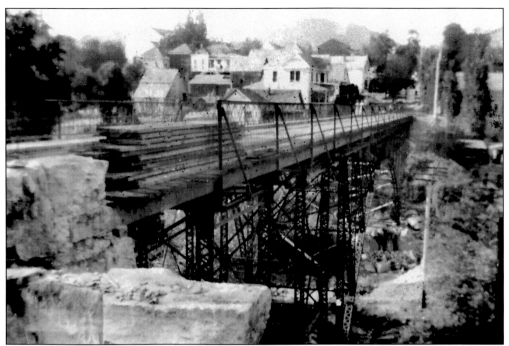

Bridges were vital to a county with so many rivers and creeks. Nevada City was built up around Deer Creek. This rare photograph shows the construction of the suspension bridge that replaced one that collapsed in 1862 and was torn down in May 1903. It would later be named the Gault Bridge, after Alexander Gault who died in May the same year. (Author's collection.)

This is believed to be the first wagon to cross the bridge after it was completed. This very old photograph was restored to show the horses pulling a wagon across the bridge. A. A. Hallidie, builder of the bridge, would later become famous for his San Francisco cable cars. (Author's collection.)

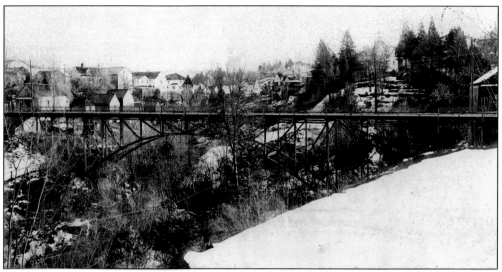

The Gault Bridge was a popular postcard view. Eighteen days after the bridge was completed, it collapsed. Two teamsters were killed, and two footmen that were on the bridge at the time were injured. The timbers were found faulty and were replaced and the cables were restretched. Another life was lost, though, when George Rockwell stepped off the end of an unsecured plank and dropped to his death. (Courtesy of Searls Library.)

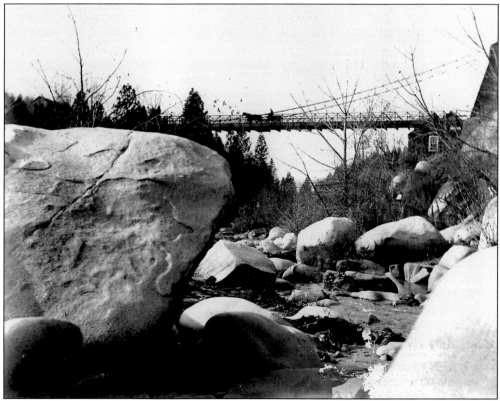

This photograph was taken from Deer Creek. In the summer, the creek could dry up, but during heavy snow and rain, the creek waters were heavy and high. (Courtesy of Searls Library.)

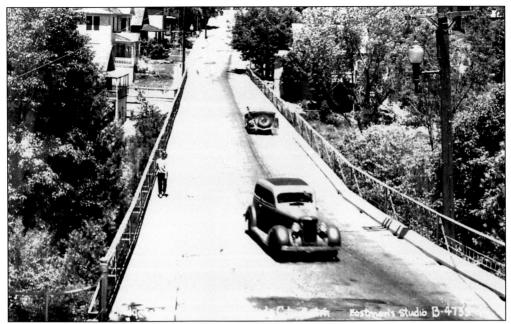

An automobile heads in each direction on the Gault Bridge. As the bridge aged, a sign was erected at both sides, allowing only one car at a time in each lane. After serving for 93 years, the Gault Bridge was replaced by a stronger bridge that opened in 1996. (Courtesy of Max Roberts.)

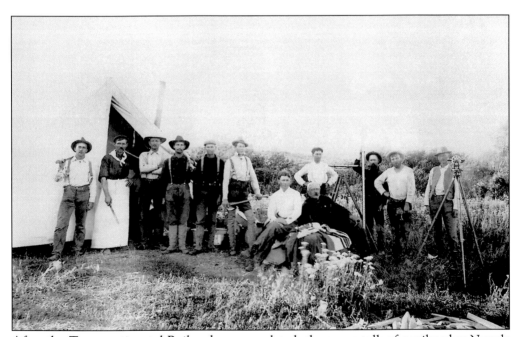

After the Transcontinental Railroad was completed, there was talk of a railroad to Nevada City and Grass Valley. This 1874 photograph shows the survey crew that set the transit through Chicago Park, Peardale, Union Hill, Grass Valley, Town Talk, and Nevada City, at work. Even the cooks helped with construction. The chief engineer is standing behind the transit. (Courtesy Ruth Chesney.)

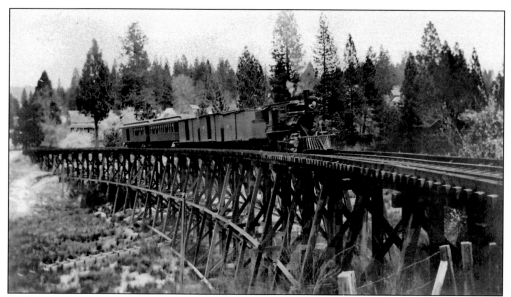

In the mid-1920s, Engine No. 2 is pulling freight and passenger cars westbound, crossing the Gold Flat trestle. Gold Flat is in Nevada City Township, one mile outside Nevada City. In 1851, there was a small mining camp there with a few cabins. By July, it grew into a small village with stores, a gambling house, boardinghouses, six saloons, and a population of 300. (Courtesy of Searls Library.)

This photograph shows the Nevada County Narrow-Gauge Railroad Station in Nevada City, before automobiles and buses. The mine owners were strong backers of the railroad for shipping gold safely out of the county to the Central Pacific Railroad in Colfax and on to San Francisco. Freight wagons lined up daily to pick up or deliver goods and merchandise to the waiting trains. (Courtesy of Ruth Chesney.)

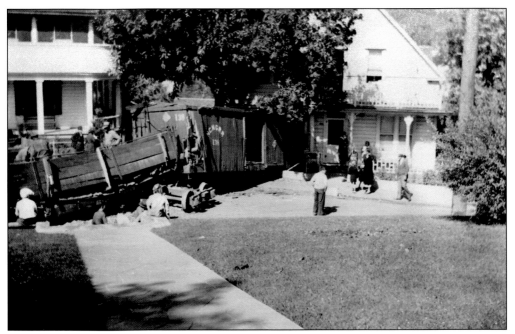

On October 11, 1937, a boxcar was thrown across the street and into the Charles Loughridge home in Nevada City. The residence would later become the Holmes Funeral Home on Adams Street. (Courtesy of Searls Library.)

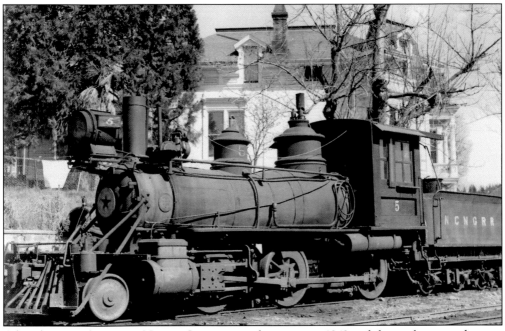

After the Nevada County Narrow Gauge stopped running in 1942 and the tracks were taken up, Engine No. 5 made a comeback as a movie and television star in Hollywood. In 1985, it would find its way back home. In 2003, Engine No. 5 would be the star attraction at the new Nevada County Transportation Museum in Nevada City. (Courtesy of Searls Library.)

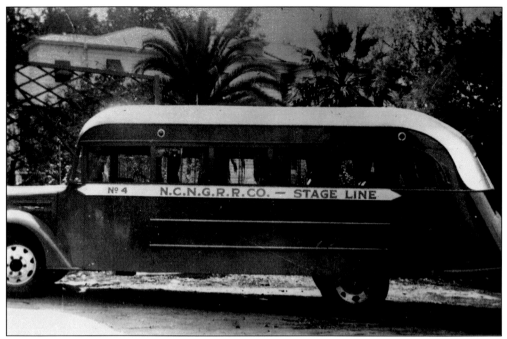

When the railroad began to decline, buses were added to service the railroad station in Nevada City. Because of traffic problems in 1934, the Nevada County Narrow-Gauge Stage had to change its parking zone for departures—from in front of the National Hotel to the bus parking zone at Broad and Pine Streets. (Courtesy of Searls Library.)

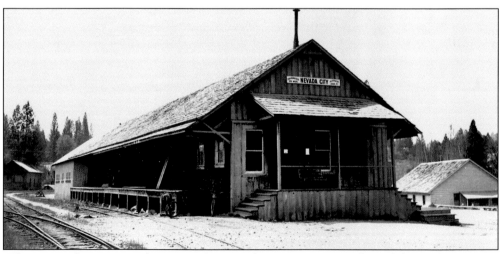

Where once there was much activity, the Nevada City station sits idle and deserted in 1940. It ceased operating as a station in 1942, a sad day in Nevada City. The NCNGRR was the only known railroad in the world to have a woman as its president. Sarah Kidder of Grass Valley was unanimously voted in after her husband's death in 1901. (Courtesy of Searls Library.)

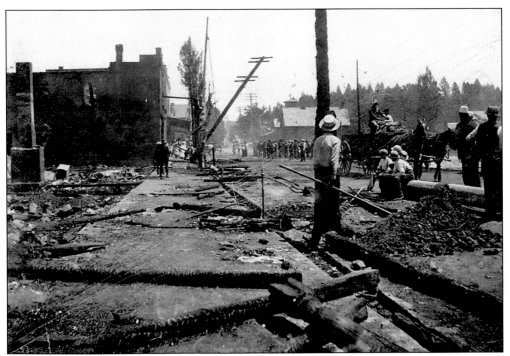

Roads are being torn up and track laid down for a new mode of transportation in Nevada City. In 1901, the Nevada County Traction Company was formed and would operate between the twin cities of Grass Valley and Nevada City, a total distance of just under five miles. It ran from Boston Ravine in Grass Valley to Pine and Broad Streets in Nevada City. (Courtesy of Searls Library.)

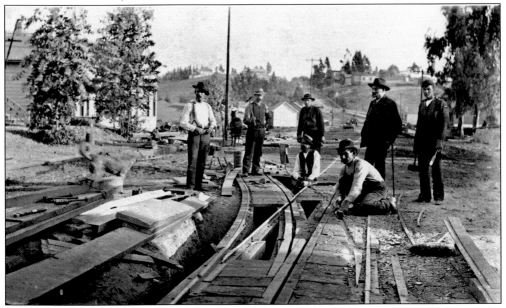

The tracks were very heavy, and there was rumor that the trolley tracks would eventually extend to Marysville in Yuba City and then all the way to San Francisco. This was never their intention and never materialized, even though standard gauge was used for the tracks. (Courtesy of Searls Library.)

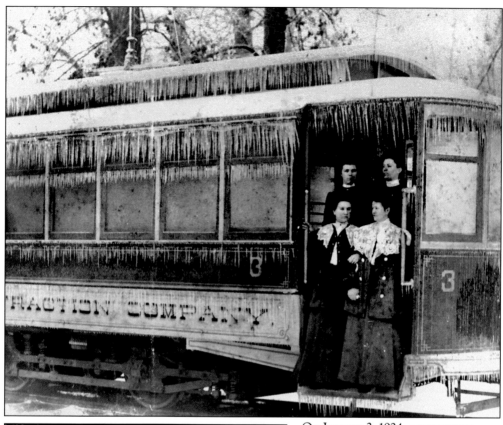

On January 3, 1924, a snowstorm completely blocked the tracks. The superintendent ordered operation to cease. Later the same day, the company president informed the superintendent to suspend operations indefinitely, leaving passengers stranded between the two cities. (Courtesy of Searls Library.)

Retha Downey was born in Nevada City and was employed by the Excelsior Water and Mining Company, next to Ott's Assay Office. At the time, the company owned 40,000 acres of land and the old Rough and Ready Excelsior Ditch. Retha and her 1931 Model A Coupe were well-known in the county. She drove from one end to the other, steadily involved in civil defense, community service, and fraternal organizations. (Courtesy of Searls Library.)

Seven

CHINESE

Thousands of Chinese came to the foothills after the gold rush began, the first arriving only a month after Marshall's gold discovery in 1848. Most Chinese spoke no English, and their dress, customs, and beliefs were profoundly different from other immigrants. They were not accepted by the great majority of American and European miners. Starting in 1852, California passed a series of laws aimed at thwarting Chinese miners, taxing them heavily for the privilege of mining.

Nevertheless, by 1860, Nevada City had a large community of Chinese along Commercial Street above Pine Street, extending to the top of Broad Street. By that time, Chinese merchants and businessmen had immigrated to California, settling in the mining communities. They imported Chinese food, herbs, and goods, and provided services to meet the specialized needs and desires of Chinese miners.

Nevada City has the largest number of Chinese buildings of any California gold rush town still standing. The oldest date back to 1880, when Nevada City had a lively Chinatown. The six buildings along Commercial Street, clustered together below York Street, are all that remain of the once-bustling neighborhood. After a June 1880 fire, the Chinese were forced to move to an area outside of town, which was also referred to as "Chinatown." Some of the Chinese merchants reestablished themselves along Commercial Street in spite of opposition from white businessmen, who thought the real estate was too valuable to be occupied by Chinese. Many residents employed Chinese in their homes as cooks and gardeners and in their businesses as laborers.

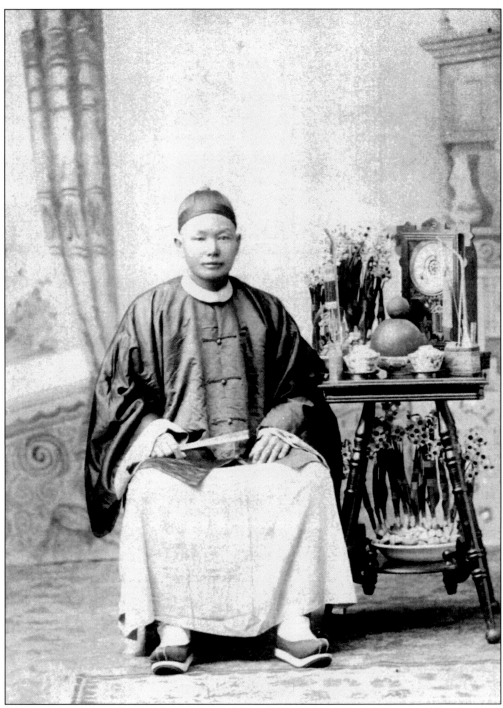

Ah Gin was born in China and arrived in California in 1873. He became a respected businessman and prominent citizen of Nevada City. The building at 311 Commercial Street, across from where the Sin Lee Laundry stood, had been leased to the Chinese as a business, and later as a residence. Ah Gin lived there and purchased the building in 1913 from the estate of the previous owner. (Courtesy of Wally Hagaman.)

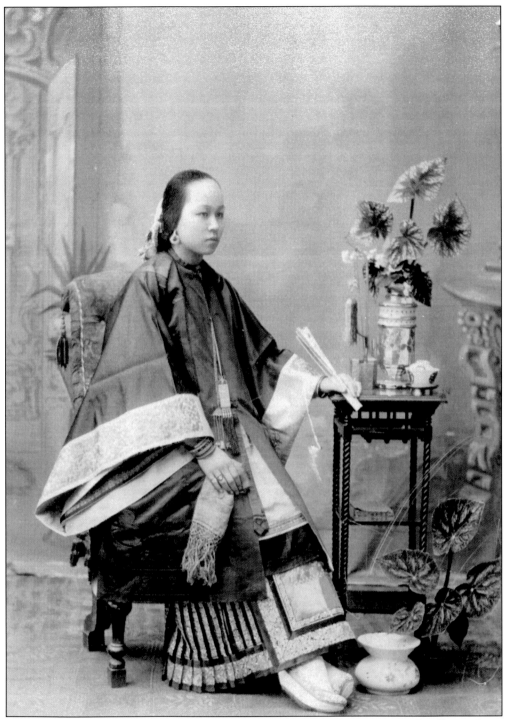

Ellen Mow Hall was born in North San Juan in 1878, attended the one-room schoolhouse there, and in 1894, at the age of 18, married Wong Lung Moon in Nevada City. The Moons operated a business in New Chinatown as well as North San Juan. (Courtesy of Wally Hagaman.)

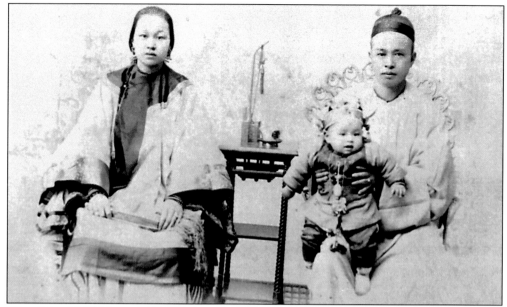

Ellen (Mow Hall) Moon was the mother of eight children, but only two sons and three daughters survived. Ellen and Wong Lung Moon traveled to China when their first son, Francis, was an infant, and they stayed almost four years. While visiting Mr. Moon's village, there was an attempted kidnapping of Francis, who hid under the bed while the kidnappers searched the house. After the bandits left, the distraught family came in looking for Francis, who came out of hiding to surprise them. (Courtesy of Wally Hagaman.)

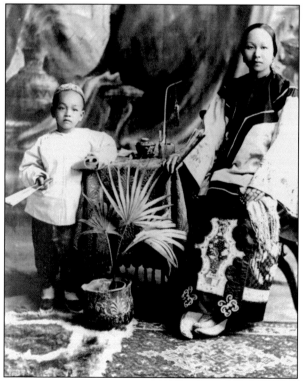

Both in traditional dress, a four-year-old Francis poses with his mother, Ellen Moon. Francis was born in 1895 in Nevada City. By the early 1900s, the Chinese population of Nevada County was dwindling. The early residents had died or returned to China and the young people often went away to school, settling where there was more opportunity. The Chinese Exclusion Act prohibited immigrants from 1882 to 1936. (Courtesy of Wally Hagaman.)

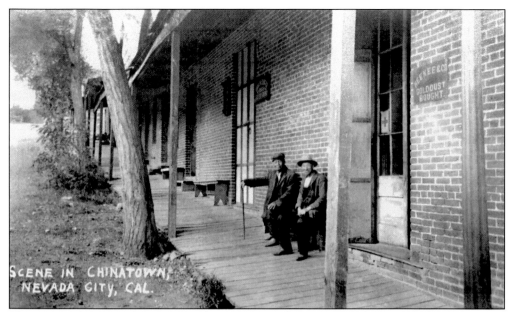

This is Nevada City's Chinatown in the mid-1920s. The row of buildings still had active general stores, barbershops, and residences. Hee Kee, whose store is shown here, was called the "mayor of Chinatown" and was a popular member of both the Chinese and white communities. (Courtesy of Wally Hagaman.)

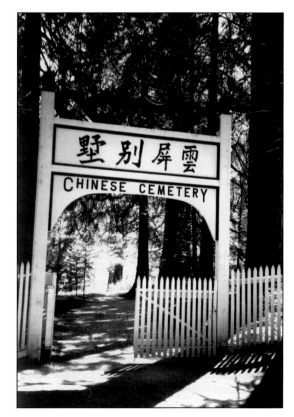

The Chinese cemetery in Nevada City sits peacefully tucked among the pines. Many Chinese arranged to have their bones shipped back to China to be buried in their homeland. Chinese cemeteries here were only temporary resting places. (Courtesy of Wally Hagaman.)

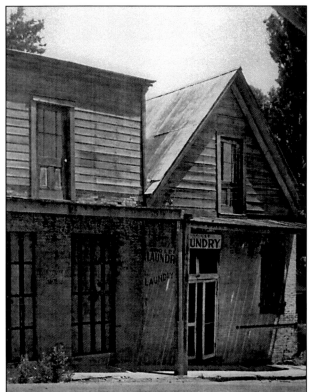

The Sin Lee Laundry was located for many years in this building at 312 Commercial Street, just below York Street. The building was built in 1885 and at one time was a store. The building to the left was constructed about 1891 as a Chinese general store. Missing is the balcony in front of the door on the second story. The two buildings are a popular subject for photographers and artists. (Courtesy of Wally Hagaman)

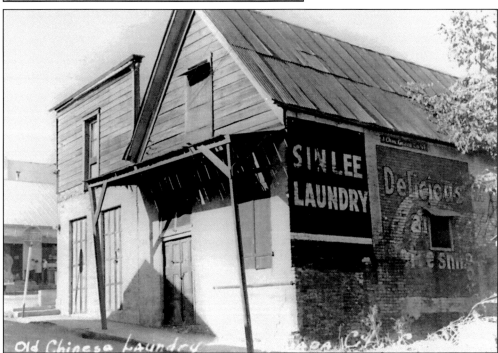

From a different angle, the Sin Lee Laundry stands deserted. In 2004, the two buildings were refurbished and the property in the back was landscaped. (Courtesy of Bob Wyckoff.)

Eight

LEISURE, ENTERTAINING, AND CELEBRATIONS

From the earliest days of Nevada City, when it was still a booming mining camp with the third largest population in the state, it was visited by the most popular entertainers of the day. These included two local performers, Lotta Crabtree and Emma Nevada. John Wilkes Booth and world-famous Lola Montez, who lived for a short time in nearby Grass Valley, entertained crowds in both towns. Mark Twain performed twice in the oldest theater in the West, the Nevada Theatre.

The town had a reputation for being cultured and was included on the circuit of the most popular speakers of the day. James Marshall, who had mined on Deer Creek years before, spoke in Nevada City, as did Susan B. Anthony, a personal friend of prominent local resident, Ellen Sargent.

Great celebrations on the Fourth of July alternated between Grass Valley and Nevada City. This tradition is still carried on today and is one of the most celebrated events for local residents and tourists alike.

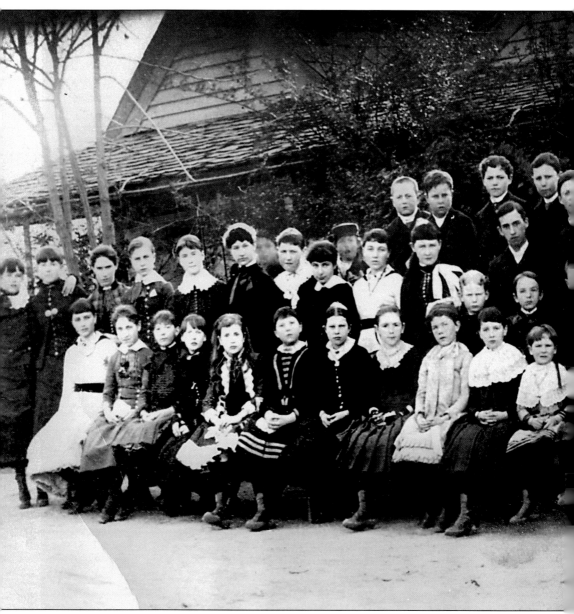

The Temperance Hall was located on Sacramento Street. In the early 1880s, it was destroyed in a fire. George Gehrig, owner of the brewery, erected a dance hall where John Mitchell held Saturday night dances and dancing classes for adults in the evenings. Children's classes were held on Saturday afternoon. This photograph was taken across the street from the dance hall in front of the residence of John Dunncliff. From left to right are (first row) unidentified, Annie Webber, Charlotte Isoard, Corrinne Tower, Alice Caldwell, Mabel Charles, Annie McCrandall, Mattie Grant, Maggie Heather, Helen Cooper, Ethel Mulloy, Minnie Maltman, Laura Power, Grace Garthe, Becky Baruh, Helen Shurtleff, Maggie Organ, Carrie Groves, Jennie Brown, Vivie

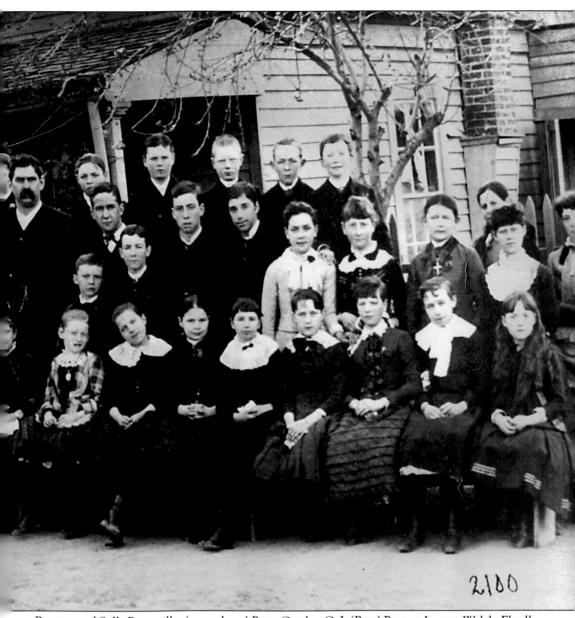

2100

Rector, and Sally Percaville; (second row) Butts Garthe, G. J. (Bert) Rector, Lyman Welch, Elwell Holland, and John Jack; (third row) Mamie Potter, Edith Bradley, Jennie White, Louvia Ott, Julia Hook, Bertha Webber, Mamie Groves, Jennie Baruh, unidentified, Lucretia Dower, Ester Kistle, Harry Potter, Compton Gault, Barnum Power, Clarence Organ, Teresia Siebert, Adah Rich, Lottie Locklin, Myrtis Charles, Stella Beardsley, and Frankie Power; (fourth row) George Legg, Louis Swartz, Lowell Mulloy, Clarence Maltman, Watson Charles, George Barton, Fred Lester, John Mitchell (teacher), unidentified, Will Hoskins, Tom Richards, Clifford McCutcheon, and Carl Brand. (Courtesy of Searls Library.)

Balls and masquerades were very popular events, especially during the winter season when outdoor activities and travel was limited. Florence (Rowe) Craig is dressed for a masquerade ball. William Crawford advertised in the *Transcript* that he had an assortment of "fancy and comic" costumes on display for masquerade balls. Special orders could be made from a catalog, and he carried a full line of masks for sale. (Courtesy of Searls Library.)

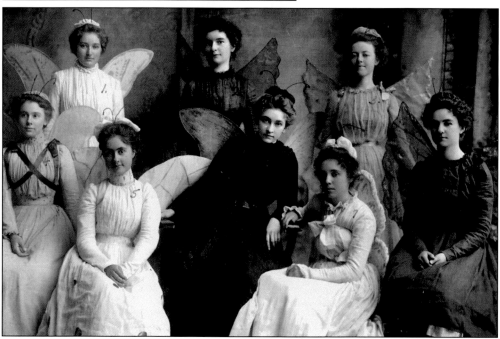

Nevada City High School's carnival on November 22, 1923, at the Armory Hall was one of the school's greatest successes of the year. The Butterflies sang and danced in two choruses. Seen here and numbered from top left are (1) ? Carr, (2) Maud Easin, (3) Beatrice Carr (Cassidy), (4) Minnie Kahl, (5) Lenore Steger (Coughlin), (6) unidentified, (7) Dora Organ, and (8) Mollie Maher. (Courtesy of Searls Library.)

The house where Emma Nevada Palmer (Emma Wixom) once lived with her family on Broad Street was built in the 1850s, and was at one time the Methodist church parsonage. The world-famous operatic singer was born in the town of Alpha in 1858 and lived in Nevada City only about six months. Emma returned to Nevada City in 1902 to visit and perform. She was welcomed like royalty by local residents. Emma Nevada became a world-famous soprano and began her singing career in Nevada City's Baptist church. She was three years old and so tiny that she was placed a table when she sang the "Star-Spangled Banner." (Courtesy of Searls Library.)

When James W. Marshall, the discoverer of gold at Coloma, visited Nevada City on an April 1870 statewide tour, he recalled to the audience the story of an 1848 visit during which he conducted a train of immigrants through the area and camped overnight on Deer Creek. He panned out some dirt and got a little color, but did not make a large find. (Courtesy of Searls Library.)

Lotta Crabtree, like Emma Nevada, was a famous singer of Nevada County. She appeared in 1857 at the Nevada Theatre and in 1858 at the Temperance Hall. When she lived in Grass Valley (1853–1855), Lotta was taken under the wing of Lola Montez, who recognized the child's talent. Montez herself gave several performances at the Dramatic Hall in Nevada City. (Courtesy of Searls Library.)

The Curley Bears may have just liked to dress up between masquerades. As part of the Native Sons of the Golden West, they appeared in parades, conventions, and generally seemed to have a good time. Pictured here, from left to right, are (first row) unidentified, George Calahan, Ed Schmidt, Fred Brown, and Max Isoard; (second row) Lee Garthe, Fred Zeither, Fred Arbogast, and David Morgan. (Courtesy of Searls Library.)

The Nevada City Opera Club, posing here in June 1893, included Minnie Lester, unidentified, Carl Brand, Myers Preston, Effie Power, unidentified, Annie Weber, Maggie Organ, Oran Clarence, Mrs. Chapman, Alice Cooper, two unidentified, Carrie Naffiziger, Edith Gueather, Mary Hoskins, Herbert Casper, Bertha Weber, and Annie Clemo. (Courtesy of Searls Library.)

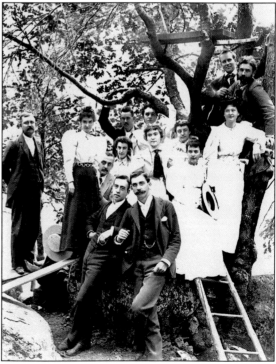

Erasmus Barnum Power was the son of Nevada City pioneers Francis Power and Elizabeth Julia Kent. In June 1894, Power, front right, poses with family and friends. He married Minerva Lester, the granddaughter of Zeno Philosopher and Sarah Davis. They lived at the Davis home on Spring Street for several years after they married. Power was a popular attorney and became the district attorney from 1894–1901. (Courtesy of Ruth Chesney.)

Nevada City's 1934 season pitted two Nevada City teams against each other. The East of Pine Street baseball players arrayed against the West of Pine Street boys. Dave Richards was the captain of the East Siders, and "Tuffy" Penrose was the captain of the West Side boys. But they weren't really boys. The West Side team included local businessmen Goyne, Penrose, Richards, Tobiassen, Kopp, and Bost. Above is the 1888 Nevada City Baseball Club. (Courtesy of Searls Library.)

In June 1893, the Nevada City Athletic Club gave a performance at the opera house with routines on the horizontal and parallel bars and the Spanish rings, performing acrobatics as well as wrestling and boxing. The star performers were George Gehrig and Frank Mahar. Pictured here, from left to right, are Gehrig, George Legg, Ed Black, William Giffin, Charlie Dennis, Frank Morgan, Sherman Costello, and Mahar. (Courtesy of Searls Library.)

Parades were popular in Nevada City. This entry turns the corner of Commercial and Pine Streets toward Broad Street. H. Dickerman Drugs is on the corner. J. C. Dickerman and his wife, Olive, arrived in Nevada City in the spring of 1850. At that time, Nevada City was still mostly forest, and trees had be cut down in order to build the house. (Courtesy of Searls Library.)

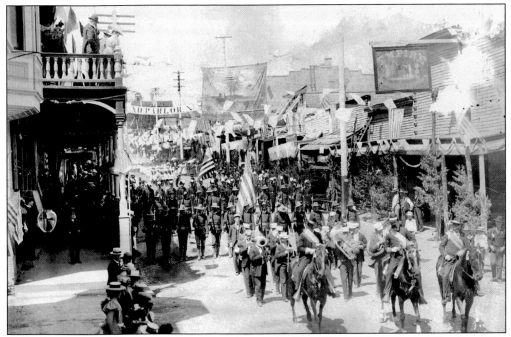

Several businesses visible in this c. 1890s Fourth of July parade are the National Hotel and the Wells Fargo Express sign (below the balcony on the left). The National Hotel balcony has always been a favorite spot from which to view parades. Across the street is the Empire Livery where Alpha Hardware would be built. (Courtesy of Searls Library.)

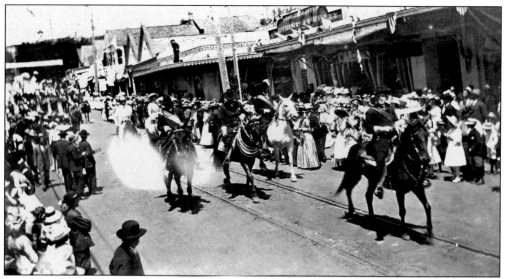

Everyone stands to watch this c. 1890s Fourth of July parade marching down Broad Street on the trolley tracks. There are no benches or grandstands, and people dressed in their Sunday best despite July heat in Nevada City. The sign on the building at top right reads "Twin Cities Clothing Company." (Courtesy of Ruth Chesney.)

The volunteer fire departments were respected and important citizens of the community. This float (date unknown) was sponsored by the Nevada City Firemen. To the right, the group of men pictured, from left to right, are George Legg, Mr. Hood, and L. Tully. Early parades were not only well attended, but supported by donations from the community. (Courtesy of Searls Library.)

In 1912, members of the Native Daughters of the Golden West Laurel Chapter included (first row) Minnie Smith as Betsy Ross and Muriel Grimes, grand marshal; (second row) Vera Hopkins as Liberty, Frances Perryman as Minerva, and F. Guenther, Miss Nevada City. (Courtesy of Doris Foley Library.)

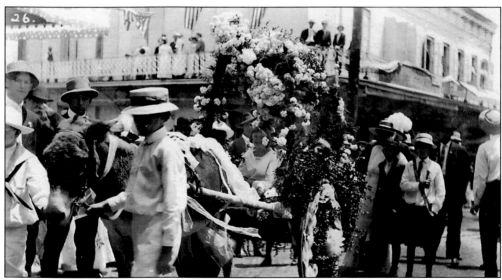

This is the 1910 Nevada City Fourth of July parade going up Broad Street past Pine Street. Seated in the cart is Ruth Fitter (Chesney) and Bertha Marie ?. Today's parades come down Broad Street with motor-powered entries. Those past Nevada City residents must have been made of hardier stuff as they walked and pulled carts in the July heat. (Courtesy of Ruth Chesney.)

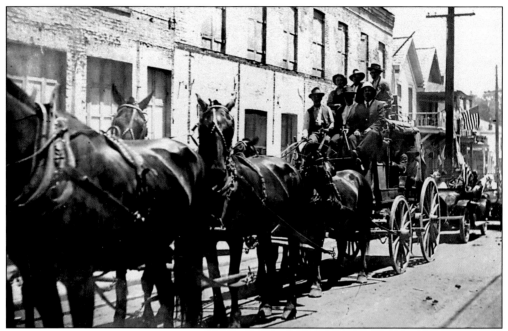

William Meek drives his team in the 1912 Fourth of July parade in Nevada City. Automobiles are lined up behind him. Seated with him are mail messenger William H. Landrigan and George B. Finnegan. On top sits Henry Jacobs Jr., Toughy Brown, and Howard Mike Willie, while in the coach is Pap Brophy.

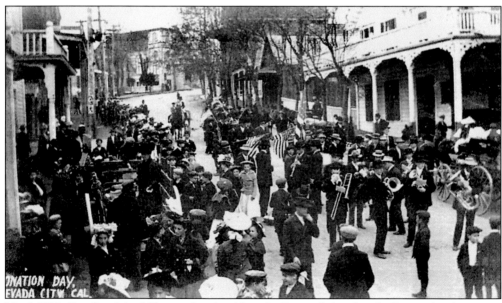

Until 1880, Caroline Mead Hanson lived in Nevada City with her family. During hard times in 1883, Caroline wrote a letter from her Grass Valley home to the editor of *The Union* suggesting that each child bring one potato and a stick of stove-wood to school on the same day of the week. The next day, the Ladies Relief Society would pick them up and deliver them to those who were most in need. (Courtesy of Ruth Chesney.)

Nine

COMMUNITY AND GROUP SHOTS

Those who came to Nevada City from other parts of the country brought with them memories of groups and organizations they belonged to back home. Others invented things to fill the leisure time of the mostly industrious citizens, young and old alike. Community socials and outdoor activities were popular in Nevada City and friends and family from surrounding townships came to share the many community events. Dances, masquerades, grand balls, concerts, and parties of every variety kept the residents busy. In the summer months, picnics, fishing, hunting, and camping were popular, in particular the annual Miners' Picnic and Pioneers' Picnic. School and church picnics were often held on ranches in the outlying areas to accommodate large crowds. Bear Valley was a favorite place to camp, along with other up-county lakes and rivers.

Many events were held at Glenbrook Race Track, Olympia Park, Storm's Ranch, and Shelby's Pond. One annual event sponsored by the Native Sons and Daughters of Nevada City was the Pioneers' Reception in honor of the pioneer men and women who came to Nevada Township before 1860. Invitations were sent out and former residents came from all parts of the country to attend.

Beginning in the 1870s, an extremely popular social event was the Young Men's New Years Party, known as the event of the season. The Young Men's Social Club was for bachelors, and whenever a member committed the "constitutional crime of matrimony," he was formally read out of the club, the ceremony taking place at the residence of the guilty party, and the penalty being his obligation to provide an evening's entertainment and banquet for the other club members.

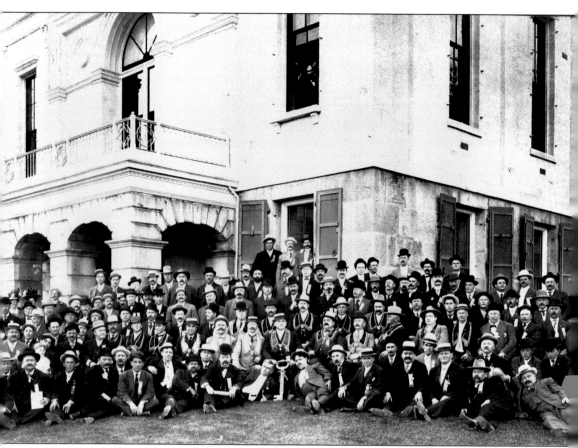

Democratic delegates pose in 1908 in front of the courthouse in Nevada City. Beginning on September 9, a Democratic Convention was held in Nevada City. Locally, Judge Nilon was running against J. M. Walling, an ex-judge. There had been a bitter debate in the newspaper between Judge Walling and Dr. C. W. Chapman, chairman of the Republican Central Committee, regarding the use of colored ballots for voting, thereby destroying the secrecy of the ballot. During the convention, a speech was heard by William Jenning Brayn via a phonograph recording. It was a nonpartisan speech on immortality. Buggies were provided by both Republican and Democratic parties to bring voters to the polls. (Courtesy of Searls Library.)

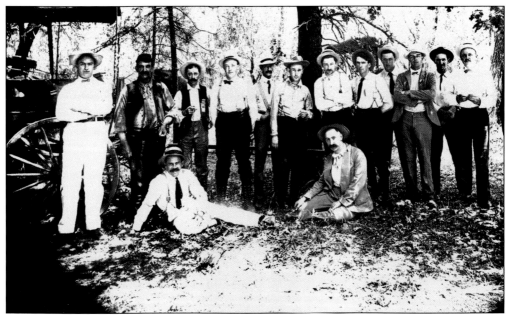

The annual Dove Stew was an event that sportsmen and their guests looked forward to each year. It was held at various locations over its long history. In 1913, the 29th-annual dove hunt and camp stew has held at the Dickerman grove in Penn Valley. The location was one of the most favored spots for having the stew and required little work to get it ready besides setting up the kettles and the fire. (Courtesy of Searls Library.)

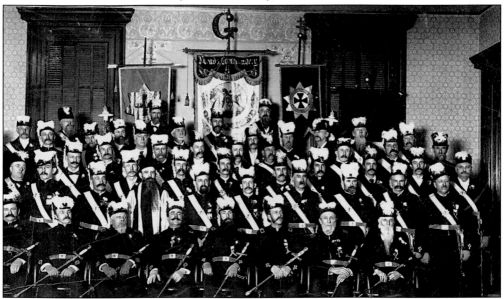

In 1850, Nevada Lodge No. 13 of the Free and Accepted Masons (F&AM) formed and was the largest and most thriving in California at one time. In that early period in public life, the lodge provided two U.S. Senators, one judge of the U.S. District Court, and two California Supreme Court judges. The Nevada Commandry was issued a Dispensation in 1858, and members included Searls, Caswell, Marsh, Dibble, Hawley, Van Decar, Boring, Bope, Reis, and Ferguson. (Courtesy of Searls Library.)

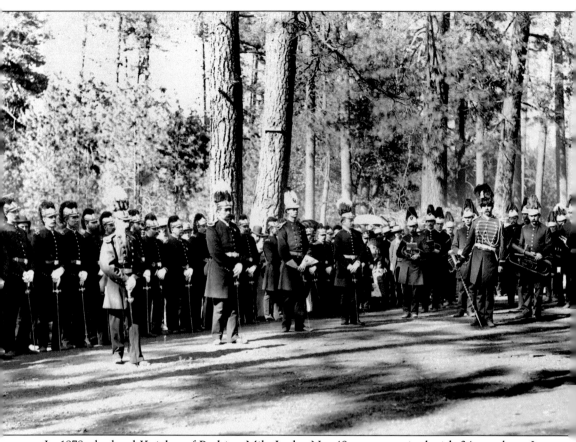

In 1878, the local Knights of Pythias, Milo Lodge No. 48, was organized with 34 members. It was a popular organization that increased its membership to 120 by its fifth anniversary. In this June 14, 1896, photograph, dressed in their uniforms and holding swords, the Pythians are at Storm's Ranch for their annual picnic. The meetings were held at the "Pythian Castle" where they conducted business, dined, made speeches, and sang songs. In 1885, the Pythian Castle was in a hall located in the Morgan and Roberts block (Kidd and Knox). In formation at the corner of Pine and Broad Streets, the first officers were George M. Hughes, J. W. Robinson, J. A. Rapp, Oscar Maltman, J. G. Hartwell, G. A. Gray, Joseph Fleming, W. D. Vinton, A. R. Lord, and H. S. Welch. (Courtesy of Searls Library.)

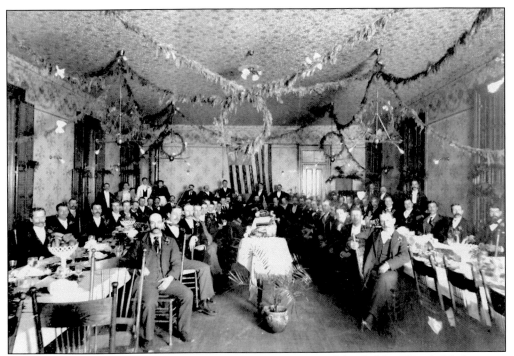

On March 15, 1897, the Hydraulic Parlor of the Native Sons of the Golden West held a banquet in honor of the Grand Trustee of the Native Sons, Milton D. Garratt. In addition to the banquet, the program include music by Phil Goyne's orchestra. Photographer Edward A. Moore was there to take "flash-light" views of the banquet. The banquet was held at the elegant Victorian Union Hotel on Main Street. (Courtesy of Searls Library.)

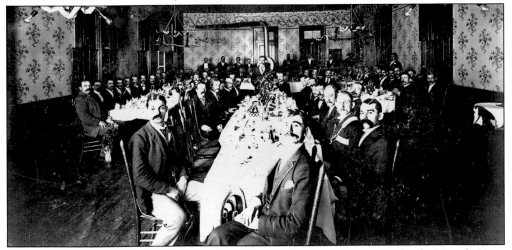

This was a banquet given to celebrate the adoption of a new water system by the Nevada Hose Company No. 1 on November 9, 1895, at the popular Union Hotel. The Pennsylvania Engine Company invited a number of friends to join them as they marched up Commercial Street and around the block to the Union Hotel. Pictured are Charles McEgan, chief; Tom Garrison, steward; John A. Rapp; J. B. Gray; J. J. Hanley; J. F. Hook; T. H. Carr; L. S. Calkins; C. J. Brand; S. Butler; A. V. Hoffman; and A. W. Morris—just a few of the men in attendance that night. (Courtesy of Searls Library.)

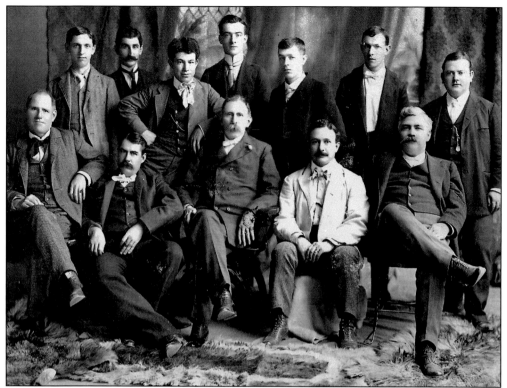

Nevada City businessmen pose with Wylie W. Giffin (seated, center). Giffin was a tobacconist, owner of Giffin's Cigar Factory on Broad Street. Giffin was criticized and poked fun at in a 1887 article in the newspaper for proposing to form a joint-stock company to build a toboggan slide on Sugar Loaf Mountain above Nevada City. (Courtesy of Searls Library.)

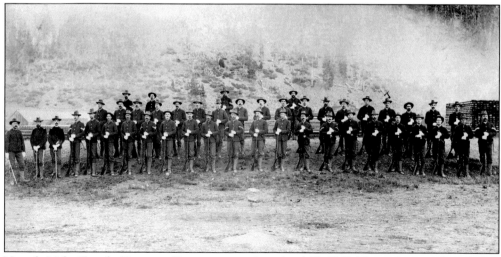

Nevada Light Guards, Company C was organized on April 18, 1863. The only man identified in this c. 1888 photo is Daniel Fletcher (back row, fourth from the left). Fletcher was the brother of young Sherman W. Fletcher, a former District Attorney who died in the 1856 fire. Published in 1894, *The Reminiscences of California and the Civil War* was written by Fletcher. (Courtesy of Searls Library.)

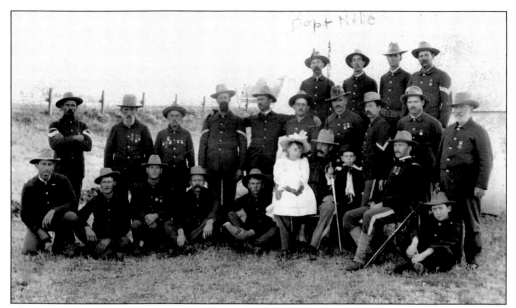

The Nevada Light Guard, Company C poses with two children on the Fourth of July 1878. Known to be in this photograph are Charles Putty Grimes and Captain Niles. They marched in every Fourth of July parade along with the two military units from Grass Valley—the Union Guard and the Howell Zouaves. (Courtesy of Searls Library.)

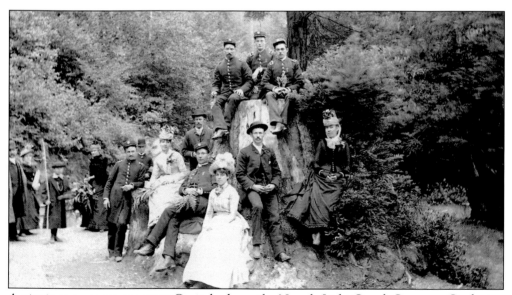

A picnic at an encampment at Capitola shows the Nevada Light Guard, Company C relaxing in the company of pretty ladies. Although they participated in community events and parades they took their duties seriously. In 1902, they were awarded the first of three state trophies against all other companies for their distinguished marksmanship in "silhouette firing." (Courtesy of Searls Library.)

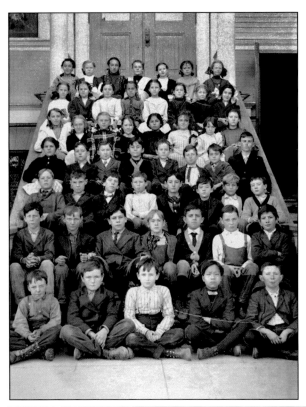

The class of 1909 at Washington School included William Morgan; the other children are unidentified. The large, Victorian Morgan house was right across the street from the school at the corner of Cottage and Main. (Courtesy of Searls Library.)

In 1920, this Nevada City girl's basketball team were the district champs. Pictured, from left to right, are Josephine Solari, Edna Maguire, Marian Rogers, Helen Bryant, Josephine Ungaro, Lillian Worthley, and Catherine Hagan. (Courtesy of Searls Library.)

In 1917, the debating team of Nevada City High School argued against a Fair Oaks team "that an international court should be established." Pictured, from left to right, are (first row) Roland Wright, Norvel Ramey, teacher Elizabeth Richards, Allen Chapman, and George Finnegan; (second row) Estelle Paine, Marguita Derby, and Janice Church; (third row) Marjory Robinson, Otis Sweetland, Clair Ivey, Bill Culver, Harry Grover, and Florence Lean. (Courtesy of Searls Library.)

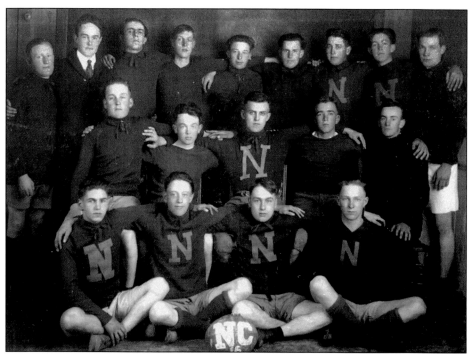

Members of the 1917 football champs of Nevada City High School, pictured, from left to right, and minus Coach Golden Tamblyn, are (first row) Allen Chapman, Edwin Rose, Dewey Johnson, and Max Isoard; (middle row) Lloyd Johnson, Vincent Foley, William Morgan (captain), Ray Pianezzi, and Frank Quigley; (top row) Norval Ramsey, Leland Johnston (manager) Victor Davison, Clair Ivey, Frank Organ, Harry Quigley, Ellis Breed, Leon Perryman, and Carlyton Johnson. (Courtesy of Searls Library.)

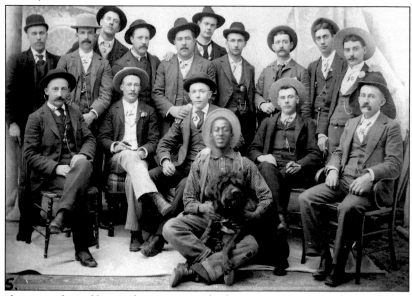

Besides a large number of benevolent, civic, and religious organizations, by 1880 there were at least 14 fraternal societies meeting in Nevada City. In this photograph, only the "mascot," Lincoln Grant, the young man holding the dog, is identified. (Courtesy of Searls Library.)